Malcolm Warner

PORTRAIT PAINTING

OVERLEAF **Rubens**: *Presentation of the Portrait of Marie de
Medici to Henry IV* (detail), 1622–5

MAYFLOWER BOOKS, INC.,

575 Lexington Avenue, New York City 10022.

© 1979 by Phaidon Press

Library of Congress Cataloging in Publication Data

 WARNER, MALCOLM, 1953–
 Portrait Painting.

 1. Portrait Painting – History. I. Title.
 ND1300.W37 757 78–25562
 ISBN 0–8317–7094–5
 ISBN 0–8317–7095–3 pbk.

Filmset in England by SOUTHERN POSITIVES AND NEGATIVES
*(*SPAN*), Lingfield, Surrey*
Manufactured in Spain by HERACLIO FOURNIER SA, *Vitoria.*
First American edition

Beauty, frail flower that every season fears,
Blooms in thy colours for a thousand years.

THESE LINES addressed by Alexander Pope to the portrait painter, Jervas, are just one expression of the commonplace idea that portraiture immortalizes. When we look at portraits, in an art gallery or the family snapshot album, this is their most immediate fascination for us: they show us as we were before transformed by age, or they conjure up the living presence of those long dead. It was in fact the belief in life after death which gave rise to the earliest forms of portraiture. In pre-historic societies funerary portraits were receptacles for the spirits of the deceased; similarly, the ancient Egyptians believed that having a likeness made, especially in a durable material, ensured immortality. The desire to live on through one's portrait, if not literally, then at least in men's minds, has, of course, persisted. Virtually all the portraits reproduced in this book were made partly with a view to promoting the posthumous fame of their sitters. They could hardly have achieved greater success in this than being displayed, as they are, in public art galleries. But they were originally intended for quite different kinds of settings, and during the sitters' own lifetimes fulfilled more immediate functions than that of commemoration.

The 'donor portraits' are a particularly clear example. Donating works of art for the decoration of churches is a

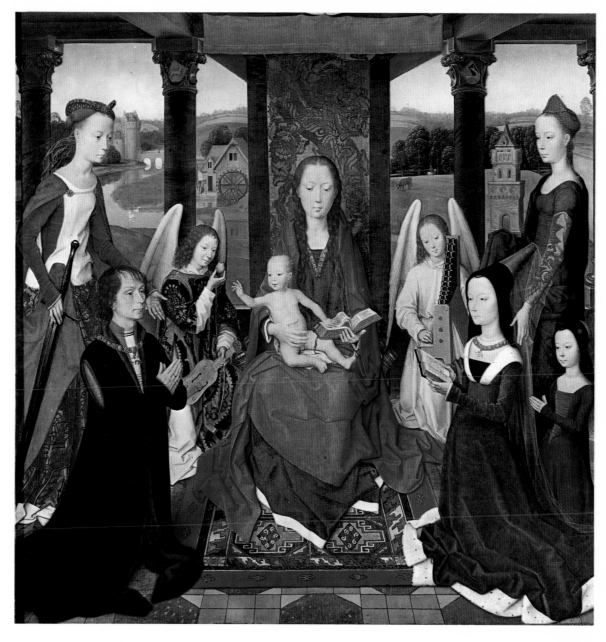

Memlinc: *Virgin and Child with Saints and Donors,* 69 × 71cm. c.1470s

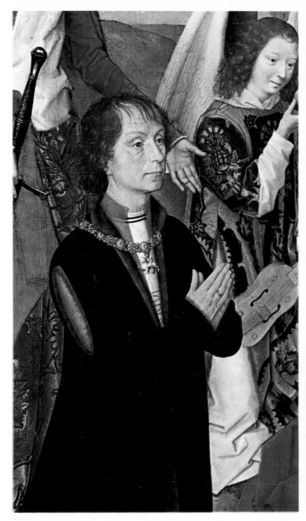 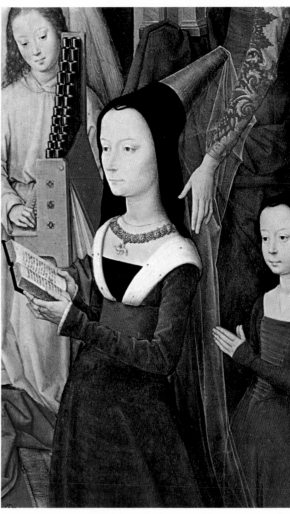

Memlinc: Details of Sir John Donne and Lady Elizabeth Donne from *Virgin and Child with Saints and Donors*

traditional way of demonstrating religious devotion. In the fourteenth and fifteenth centuries it was a frequent practice to commission a painted altarpiece for this purpose, showing oneself, and often one's family too, in the presence of divine figures. The portrait had various functions in this context. It advertised the donor's identity, to the world as well as to God; it enshrined his image in constant prayer; and represented his expected reward for the donation by showing him

in the company of Heaven. Memlinc's *Virgin and Child with Saints and Donors* is characteristic of this kind of altarpiece. The English donors, Sir John Donne and his wife, are portrayed in devotional attitudes. They are presented to the enthroned Virgin and Child by the Saints Catherine and Barbara respectively, and the Holy Infant makes a gesture of

Master of Basel: *Hieronymous Tschekkenbürlin*, 40 × 28·5cm. 1487

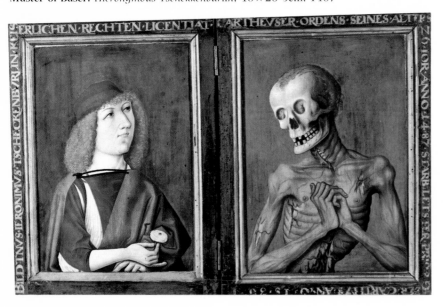

Raphael: *Madonna di Foligno*, 308 × 191cm, c.1512

The donor in the lower right corner is Sigismondo de' Conti, an historian and friend of Pope Julius II. After miraculously surviving when a meteor or fireball fell on his house in Foligno, Conti made a vow to have an altarpiece painted as an expression of gratitude to God. A work commissioned in accorance with such a vow is known as an *ex veto*, or 'votive' picture, and sometimes contains donor portraits. The *Madonna di Foligno* was given by Conti to the church of S. Maria Aracoeli in Rome which he had chosen as his place of burial. On the left are Saints, Francis and John the Baptist, and on the right Conti is being presented to Mary and the Christ Child by St. Jerome. Belief in the intercession of the saints is an important aspect of Roman Catholicism; here the choice of Conti's patron is appropriate to his occupation, since Jerome was also a scholar. The fall of the meteor or fireball is represented in the landscape background. The plaque held by the boy angel in the foreground probably originally bore an inscription explaining the vow.

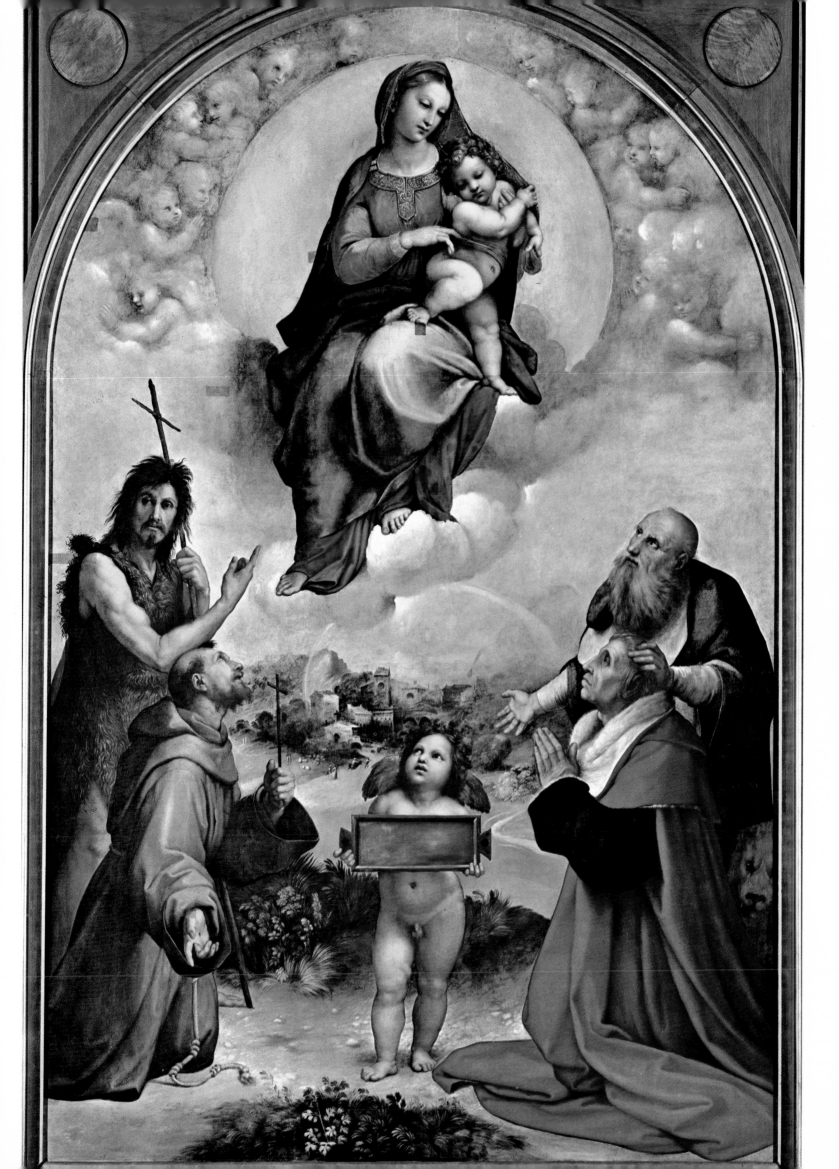

benediction towards Sir John. The couple's worldly allegiances are displayed in their family coats of arms on the capitals of the columns flanking the Virgin's throne, and in the Yorkist collar of roses and suns which each of them wears.

It was as an incidental element in works like the altarpiece with a donor that portrait painting originated, or rather, re-emerged. Portraits had been painted in classical times, but the practice had fallen into abeyance with the decline of the Roman Empire. European art between the fifth and thirteenth centuries contains no portraiture at all, in the sense in which we familiarly use the term. We may sometimes know that a figure in a medieval painting represents a particular person, but we never feel that it would help us pick him or her out in a crowd. Only in the art of the fourteenth century did the individual likeness reappear. The shift in approach is conveniently illustrated in Simone Martini's *St. Louis of Toulouse Crowning Robert of Anjou, King of Naples*. The saint is represented in the old manner. His features are stylized: they are based not on his actual appearance but on a predetermined formula for painting faces. The other-worldly quality which results is, of course, appropriate. By contrast, the face of the king – in fact Louis' own brother – is a true portrait. It is unique-looking, and hence believable as that of a particular person.

Kings hold a special place in the history of portraiture. Because of their semi-divine status they were naturally among the first to have their likenesses included in religious paintings, such as the one we have just discussed. They feature, too, in some of the very earliest secular portraits.

Simone Martini: *St. Louis of Toulouse Crowning Robert of Anjou, King of Naples*, 200×138cm, 1317

In 1317 Naples was a French kingdom. Louis had been king but had renounced his crown in favour of Robert of Anjou, his brother. Robert's claim to the throne had been much contested. When Louis was canonized he therefore seized the opportunity of implying that his legitimacy had been approved in heaven. He employed Simone Martini to paint him being crowned by Louis, who is himself simultaneously being crowned by angels. The saint is shown in the habit of a Franciscan monk, over which he wears a royal cloak bearing the arms of France and Aragon.

Titian: *Philip II*, 193×111cm, 1551

Echoes of this work can be detected in almost all state portraiture. Symbolic details such as the sword for dominance and the column for strength, the simple full-length pose, and the way in which we seem to look up at the head, even though we look down at the feet, have been endlessly imitated. As painter to the Spanish Court, Velasquez would certainly have known the *Philip II*, and his *Philip IV* may actually have been conceived as a companion, or 'pendant' to it. The two works are close in size and their general format is similar, but reversed so that they seem to match one another. Philip II was Philip IV's grandfather and so the repetition was a symbol of dynatic continuity. Both men displayed the large jaw and protruding lower lip which was characteristic of the Hapsburg family. They were similar too in the extremely solemn *persona* which each assumed. Philip II's bearing was said to be 'marked by a seriousness that to some might savour of melancholy', and Philip IV smiled in public only three times during his long reign.

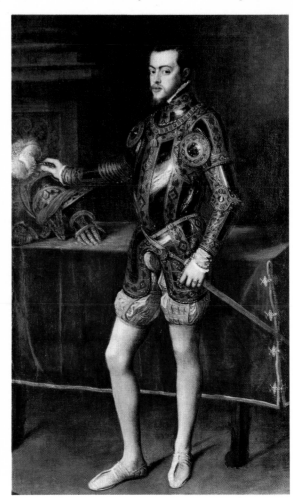

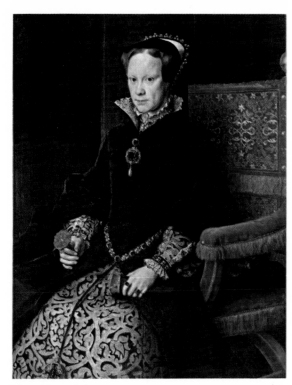

Mor: *Mary Tudor*, 109 × 84cm, 1553–4

Velazquez: *Philip IV*, 199·5 × 113cm, early 1630s

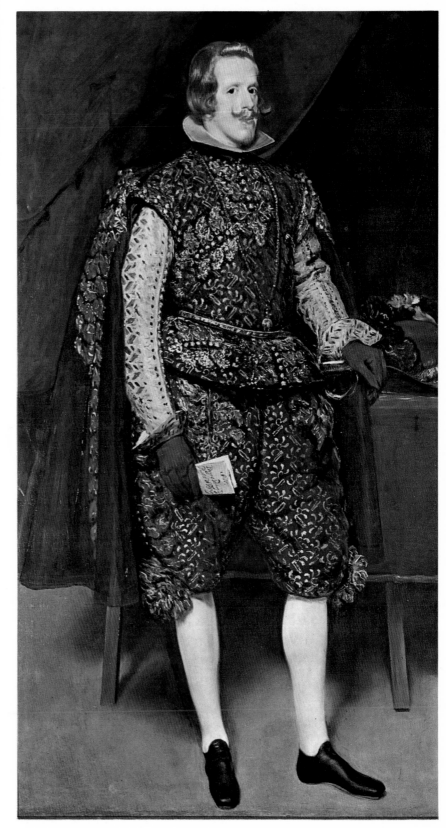

portrait of him was shipped to England, and the Dutch artist, Anthonis Mor, was sent over at the same time with orders to paint the queen. The recurrent legend of the royal fiancé who falls in love on the strength of a portrait (see frontispiece) was deliberately encouraged to make such matches seem less purely pragmatic than they were. This could hardly have been expected with Philip and Mary. But when various matrimonial prospects were equally advantageous from the political point of view, the choice of a royal spouse

Royal portraiture performed an important political function in promoting the monarch's *persona*. *Persona* derives from the Latin term for an actor's mask; it can be defined as 'appearance in the eyes of the world' and is roughly synonymous with 'image', in the sense in which the word is most commonly used today. Most kings were aware of the value of portraits for this kind of propaganda. Artists of the highest calibre were appointed to official positions at court – 'Señor Diego Velasquez, Painter to His Majesty' runs the proud signature on that artist's *Philip IV* – and they were employed to make portraits of the monarch, copies of which would be hung in palaces, council chambers and places of public assembly throughout his kingdom.

Royalty nowadays is normally presented wearing an engagingly human face. Nothing could be more alien to the nature of the royal portrait as it developed in accordance with the notion of 'Divine Right'. The monarch had to look every inch the embodiment of God-given dominion. The full-length standing portrait was found to be most conducive to this, and reached canonical status with Titian's *Philip II*. The format enabled artists to suggest a divine grace in the sitter's bearing and the proportions of his body. It also gave an impression of greater distance between him and the spectator than was possible in portraits of less than full length. Remoteness and unapproachability were essential aspects of the king's *persona*. He appeared in life much as in his portrait. Philip II, for example, received visitors in sober surroundings and subdued lighting, and would rise to his feet for audiences.

The court portraitist's skill was often put to diplomatic use. For example, portraits of visiting dignitaries from abroad would be presented to kings as gifts. But the most important part played by portraiture in international affairs was that of conveying the likenesses of prospective marriage partners. When Philip was seeking the hand of Mary Tudor, Titian's

Rigaud: *Louis XIV,* 279×190cm, 1701–2

Louis XIV, 'the Sun King', originally commissioned this portrait as a gift for the Court in Madrid, where his grandson had just become Philip V. He was so pleased with it, however, that he kept it for the throne room at the Palace of Versailles, and had a copy sent instead. In view of the original destination it is appropriate that the work recalls Titian's *Philip II.* But what we accept

as a fairly natural way of standing in the latter portrait, here becomes unmistakably a pose. The left hand moves from the sword hilt to the hip, for instance, and the right hand which rested on a helmet now drapes limply over a sceptre. This typifies the contrast between the two works. In *Philip II* we sense that dominion might exercise itself in action, in *Louis XIV* that its means are purely symbolic.

might really depend on how attractive she was in her portrait. Such was the case during the negotiations which led up to Henry VIII's betrothal to Anne of Cleves, when Holbein's portrait of her played a crucial role.

Kings are often portrayed in ceremonial dress. Where a costume is traditional, the portraitist is faced with the problem of differentiating the sitter from his similarly dressed predecessors. This, obviously, does not apply only to kings. In the Republic of Venice, for instance, painters were called upon to invent countless variations on the portrait of their head of state, the doge, in his robes of cloth of gold. This is one of the ways in which dress impinges on portraiture; another is through the demands of fashion. Fashions often originated at court, and on occasions with the monarch himself. The planar collar, or *golilla*, worn by Philip IV in his portraits was instituted as standard attire at the Spanish court after a royal ordinance banning elaborate lace ruffs; it visually detaches the head from the body in a way which must have been a constant cause of distress to portraitists. The close relationship between fashion and portraiture naturally extends to variables of appearance other than dress: deportment, hairstyle and cosmetics. The painter Boucher once flatteringly remarked to Madame de Pompadour that he could never hope to capture the beauty of her

Thomas Lawrence: *George IV.* 292 × 204cm. 1822

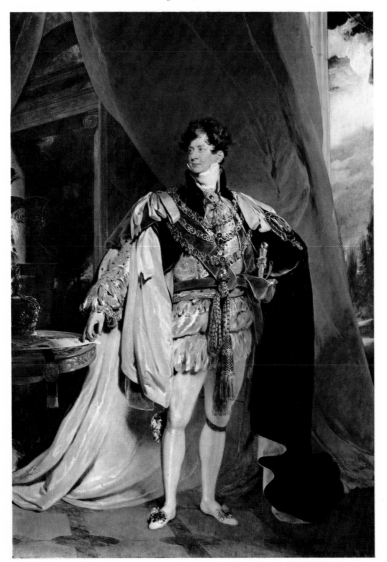

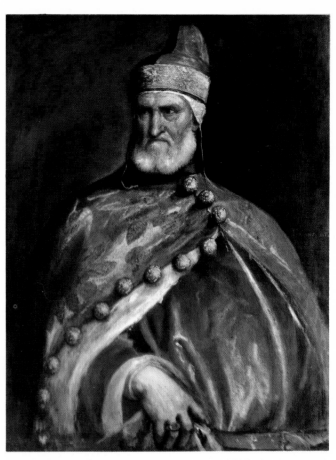

Titian: *Doge Andrea Gritti,* 130 × 105·5cm, 1535–8

colours. 'That is odd,' she replied, 'since we buy them from the same firm.'

The queen, the ladies of the court and, perhaps most of all, royal mistresses such as Mme de Pompadour, were leaders of fashion, and their portraits certainly led to the dissemination of fashion. But fashion is, by its nature, ephemeral, whereas a portrait is permanent. For this reason, specific details which would become dated were often deliberately

Giovanni Bellini: *Doge Leonardo Loredano,* 61·5 × 45cm, 1503–4

The famous sixteenth-century biographer Vasari recalled seeing a portrait of this sitter by Giorgione 'which made me think I was seeing that Most Serene Ruler in person'. This testifies to an important function of portraits of heads of State, that of serving as an *alter ego* in their absence. The passage is also interesting as an example of the use of the conventional adjective *serenissimo* for the Doge, since the word so aptly describes Bellini's portrayal of Loredano. He is as cool and immobile as the marble parapet before him. The effect is in fact that of a commemorative bust. Here power is expressed in serenity; in Titian's *Doge Andrea Gritti* it is expressed in tempestuous energy. Gritti's torso simultaneously twists and expands, seeming to burst open the buttons of his official mantle. Venetial painters were also commissioned for posthumous portraits, commemorating past doges. Titian's *Doge Niccolò Marcello* was probably based on a portrait by Bellini's brother Gentile. Marcello, who ruled in the 1470s, is said to have been the first doge to adopt the official robes of cloth of gold.

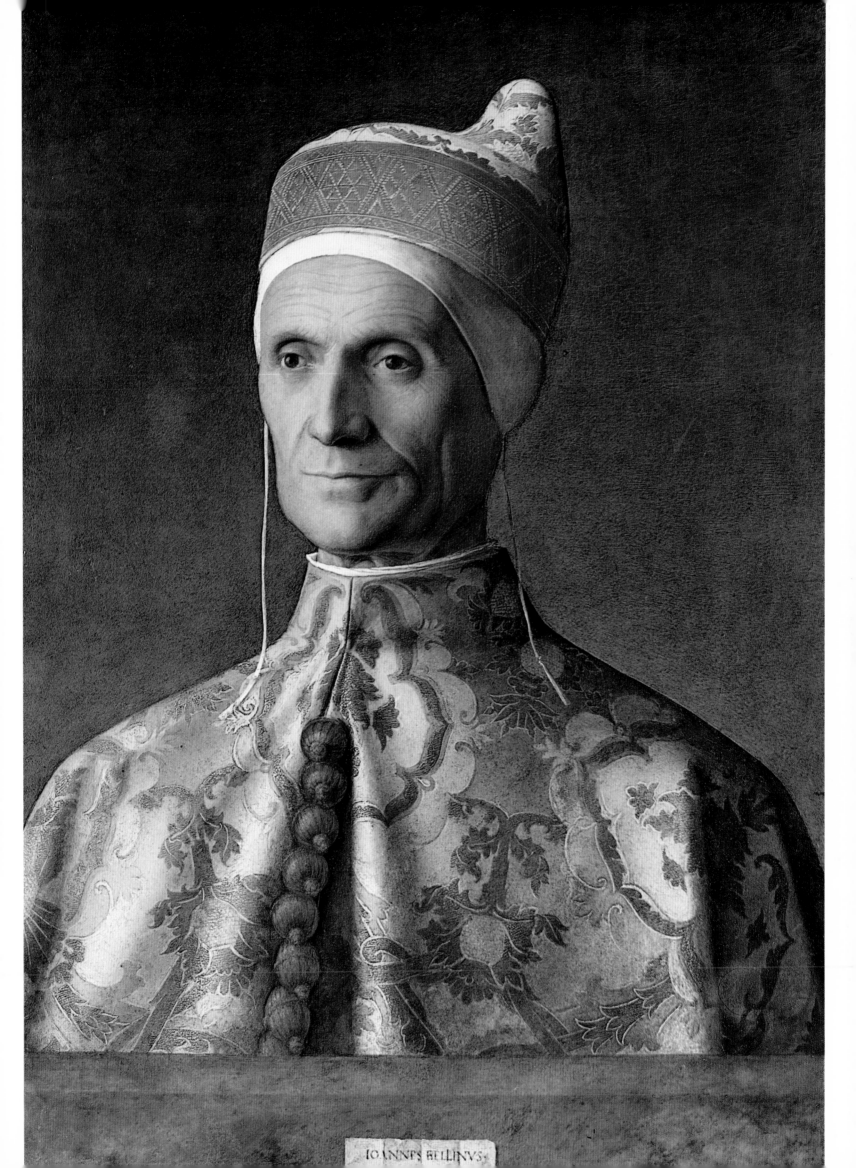

IOANNES BELLINVS.

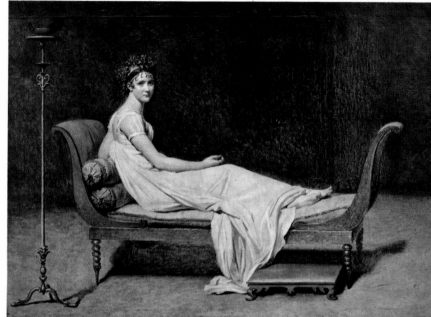

David: *Madame Recamier*, 170 × 240cm

Van Dyck: *Queen Henrietta with her Dwarf,
Sir Jeffrey Hudson*, 219 × 134cm, c.1633

Goya: *Marquesa de Pontejos*, 211 × 126cm, c.1786

avoided; sitters were even shown in some timeless fancy dress. This latter practice was popular in England in the eighteenth century, and the pros and cons of it are summarized in the following letter, written by Gainsborough in connection with a commission to paint Lady Dartmouth: 'I am well aware of the Objection to modern dresses in Pictures, that they are soon out of fashion & look awkward; but as that misfortune cannot be helped we must set it against the unluckiness of fancied dress taking away Likenesses, the principal beauty and intention of a Portrait . . .'

Rembrandt's *The Night Watch* is a fitting introduction to portraiture at lower social levels than at the court. One of the most common functions of portraiture is as a symbol of membership. Group portraits such as *The Night Watch*, of a civic militia company, exemplify this in an obvious way. Rembrandt's picture was painted to be hung in the Guildhall of the Shooting Companies in Amsterdam. Thus, not only the individual's belonging to the company, but also the company's belonging to a more general group was demonstrated. The single portrait may convey the sitter's membership by inscriptions or symbols, or again, by the context in which it is hung, such as a guildhall, the hall of a college or school, the meeting chamber of a society, or the rooms of a club.

A great deal of portraiture is associated with the idea of the family. The Romans used to display portraits of their ancestors with lines running between them, as an illustrated family tree. The same purpose, emphasizing family continuity, is served by the simpler habit of hanging family portraits in chronological order. Of course, the further back the series goes, the more impressive is one's pedigree: Philip Dormer Stanhope, Fourth Earl of Chesterfield and a famous wit, placed two old paintings of heads among his family heirlooms, inscribed 'Adam de Stanhope' and 'Eve de Stan-

14

Titian: *Doge Niccolò Marcello,*
103 × 90cm, c.1542

hope'! The advantage of portraits over written archives is that the legitimacy of the pedigree is proclaimed in the family resemblance as it persists through the generations.

The family group portrait has a long history but reached a peak of popularity in the eighteenth century. *The James Family* by Devis is a characteristic example. The setting is the James estate, and the prosperity of the family is discreetly indicated by the plain but expensive silks worn by the mother and daughters. Such works, which show two or more people in their normal surroundings and on a fairly modest scale, are known as 'conversation pieces'. The term implies some sense of communication between the members of the group.

Rembrandt: *The Night Watch (The Militia Company of Captain Frans Banning Cocq),* 359× 438cm, 1642

In seventeenth-century Holland the civic militia companies were a home guard, formed for self-defence under the threat of a Spanish invasion. Each company normally commissioned a group portrait of its members. These works, known as *schuttersstukken,* tended to show the members in rows, at a table, or standing in the company's meeting place, in a monotonous fashion reminiscent of the modern 'team photo'. Rembrandt's innovation was to introduce a narrative element. The men are engaged in a chaotic variety of activities. Their captain is giving the order to his lieutenant, Willem van Ruytenburch, to have them prepare to march. The brightly illuminated girl amongst them is a kind of mascot. She is carrying some fowl strung on her belt with the claws on prominent display. This is a visual pun: *klauw* ('claw') for *klovenier* which meant 'rifleman' or more precisely 'arquebusier'. We do not see the work now quite as it was originally hung in the *Kloveniersdoelen* (Guildhall of the Shooting Companies). It has been cut down, especially at the left side and along the top, thus making the composition appear more cramped and cluttered than it was.

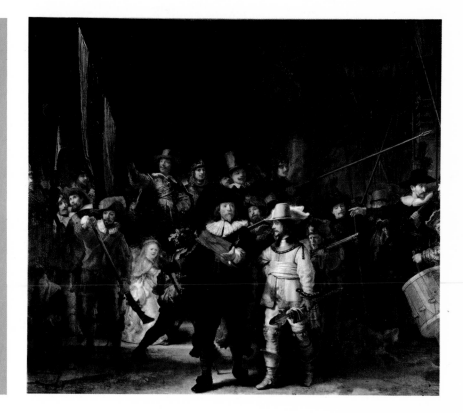

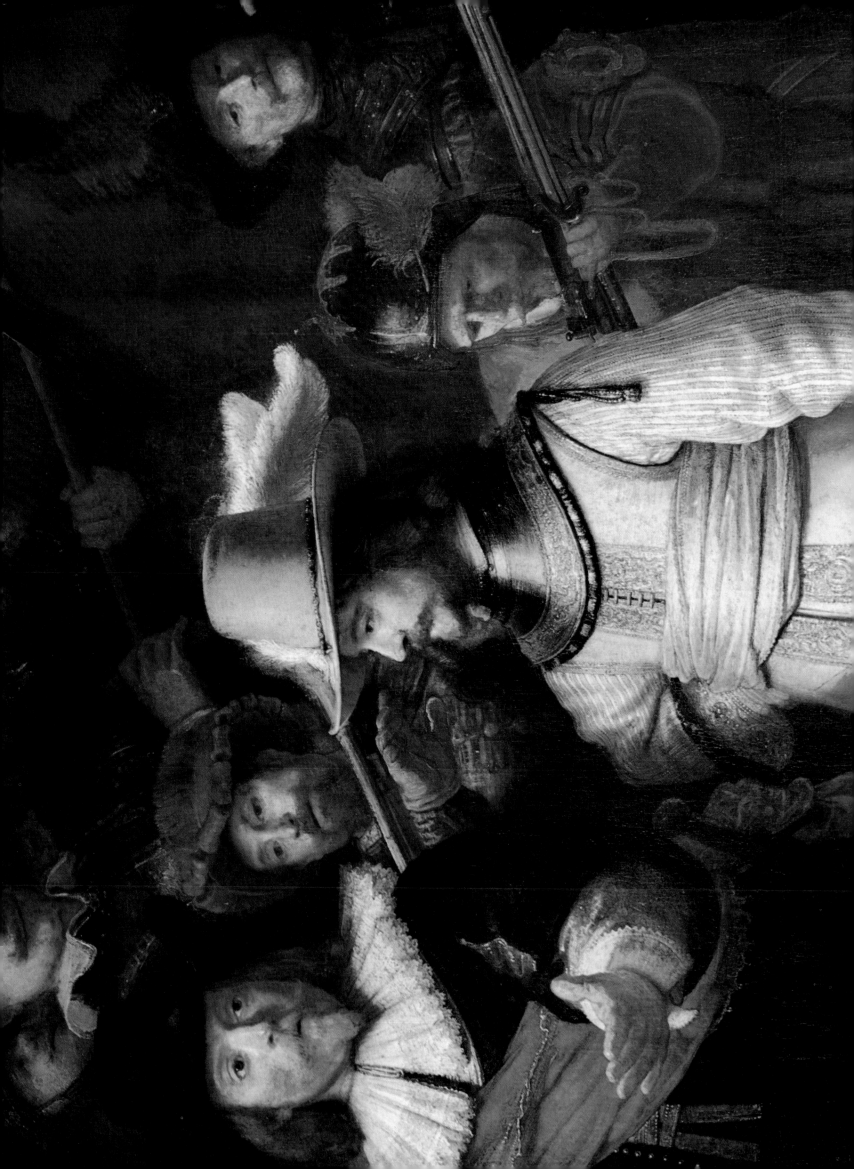

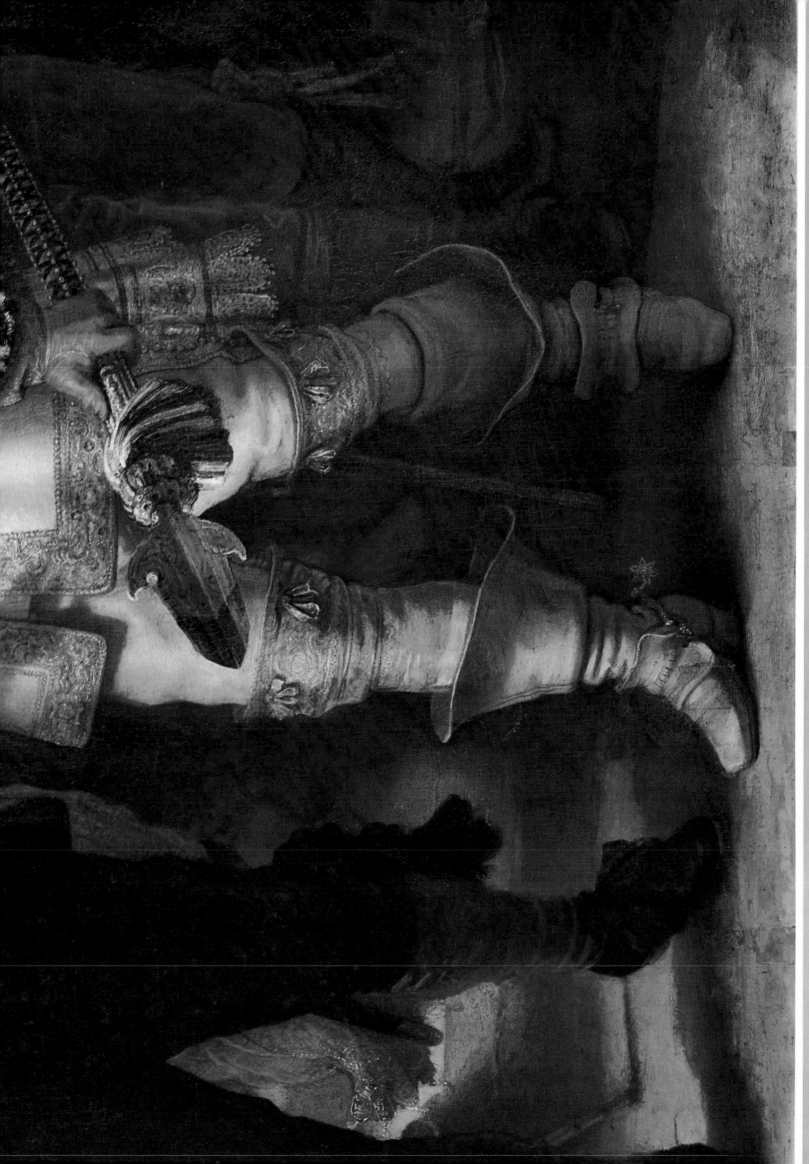

Rembrandt: *The Nightwatch* (detail)

Rubens: *Self-portrait with Isabella Brant,* 178 × 136cm, 1609

bride is usually dressed in white, but more elaborate symbolism is not normally introduced into pictures of the happy couple. Painted marriage portraits, by contrast, are often replete with significant detail. We notice, for example, that the man is on the left and the woman on the right in the works by van Eyck, Rubens and Hals reproduced here. This is because the side on which the man appears (our left but the couple's right) is traditionally associated with masculinity and dominance. When a couple's coat of arms are impaled, the husband is similarly represented on the 'dexter' and the wife on the 'sinister' side. The same principle is generally applied in 'donor portraits' of couples, and, often, too, when a couple is shown in pendant (that is matching) portraits: the husband faces more to our right and the wife to our left so that they are visually related when the separate works are hung together.

Rubens' *Self-portrait with Isabella Brant* and Hals' *Married Couple* contain other allusions which seem cryptic to us, but which were more easily appreciated by contemporaries. In the seventeenth century, richly illustrated 'emblem-books',

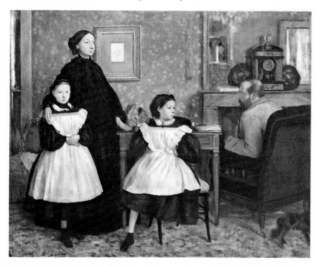

Degas: *The Bellelli Family,* 200 × 250cm, 1858–61

This is far from being the case in Degas' portrait of his aunt Laura with her husband and daughters. With its atmosphere of tension and estrangement, *The Bellelli Family* is family portraiture of the most private possible kind.

People have portraits made at important moments in their lives, and most of all on the occasion of their marriage. We are all familiar with wedding photographs; they are an almost indispensable adjunct of the ceremony. The modern

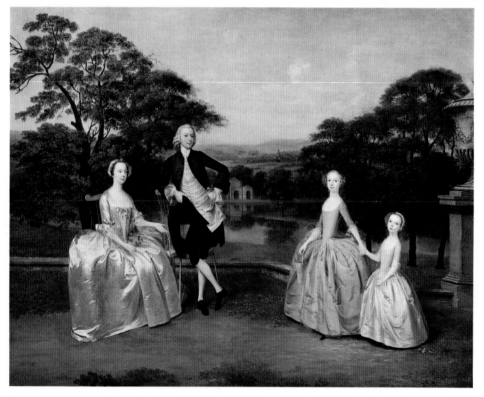

Devis: *The James Family,* 71 × 124cm, 1751

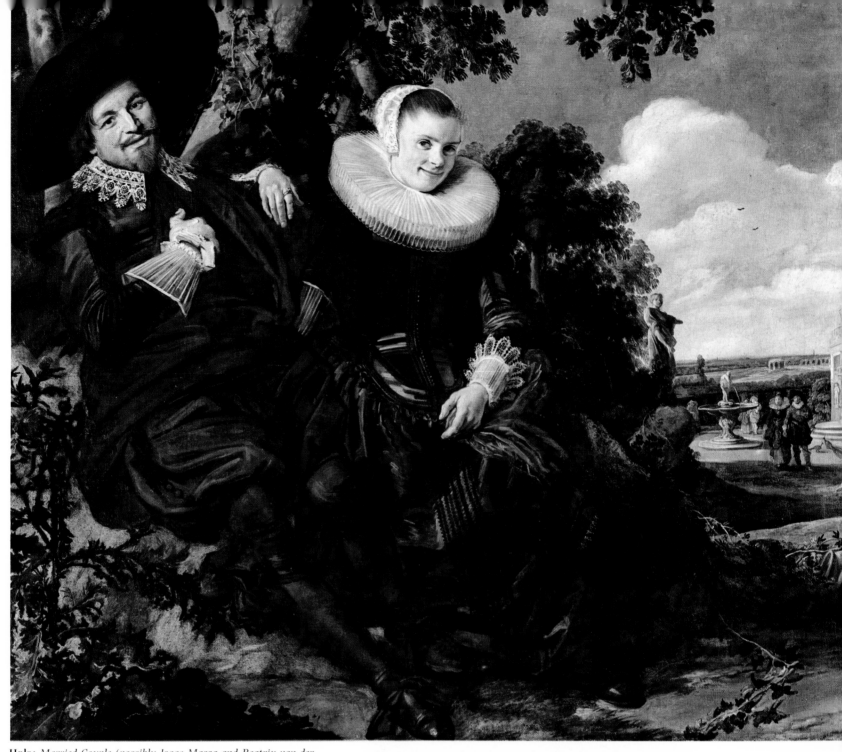

Hals: *Married Couple (possibly Isaac Massa and Beatrix van der Laen),* 140×166·5cm, c.1622

in which sayings and abstract concepts were visualized in symbolic images, provided much source material for artists. One of these showed 'Marital Fidelity' as a couple sitting on a bank by a tree. Both the Rubens portrait, painted in the year he married Isabella Brant, and Hals' *Married Couple* consciously refer to this image. Further allusions in the latter work are most obviously the prominent wedding ring, the thistle in the lower left corner and the ivy in the lower right, which both symbolize love and fidelity, the vine growing round the tree between the couple's heads which is emblematic of marital dependence, and lately, the peacocks in the background which are the symbol of the goddess Juno, patroness of marriage.

Dürer's *Self-portrait* of 1493 was painted as a bethrothal gift for the artist's future wife. The plant he is holding is eryngium, the German name for which means 'man's fidelity'. Here the portrait plays a part in courtship; it is presented as a gesture of devotion and kept as a memento of the

Pages 20–21. **Jan van Eyck:** *Arnolfini Marriage Portrait,* 82×60cm, 1434

Giovanni di Arrigo Arnolfini, an Italian merchant who spent a good deal of time in Bruges on business, is shown with his new wife, Jeanne de Chenany. They are in the very act of making their marriage vows. The portrait is a documentary record of this, and the artist is a witness: his image appears in the convex mirror on the back wall, and above it is inscribed *Johannes de eyck fuit hic* ('Jan van Eyck was here'). The discarded shoes indicate that we are on sacred ground, and the unruffled bed symbolizes the virginity of the bride. Above the couple's heads a single candle burns in the chandelier suggesting the presence of God. The dog at their feet has two possible meanings. It can be seen as the opposite to the candle, showing that humanity occupies a position between the divine and the animal, or it can be read more simply as a symbol of fidelity.

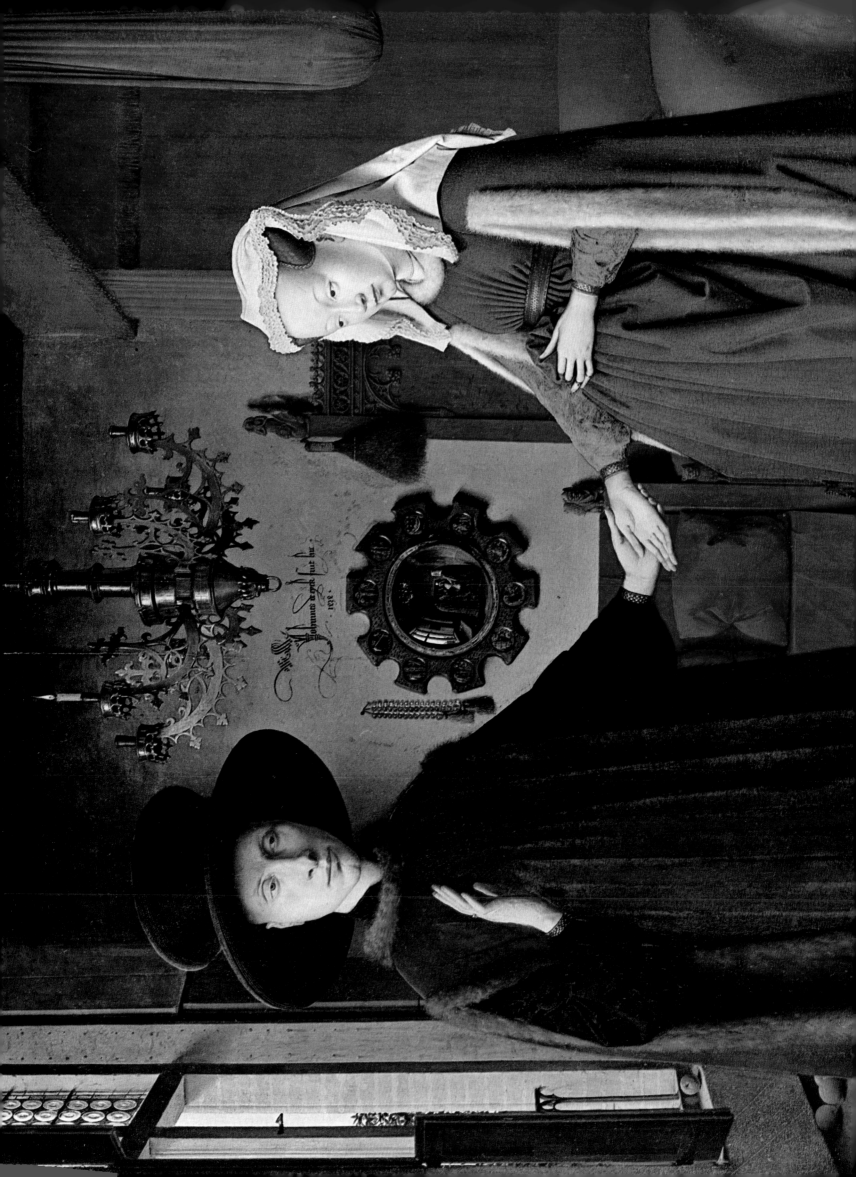

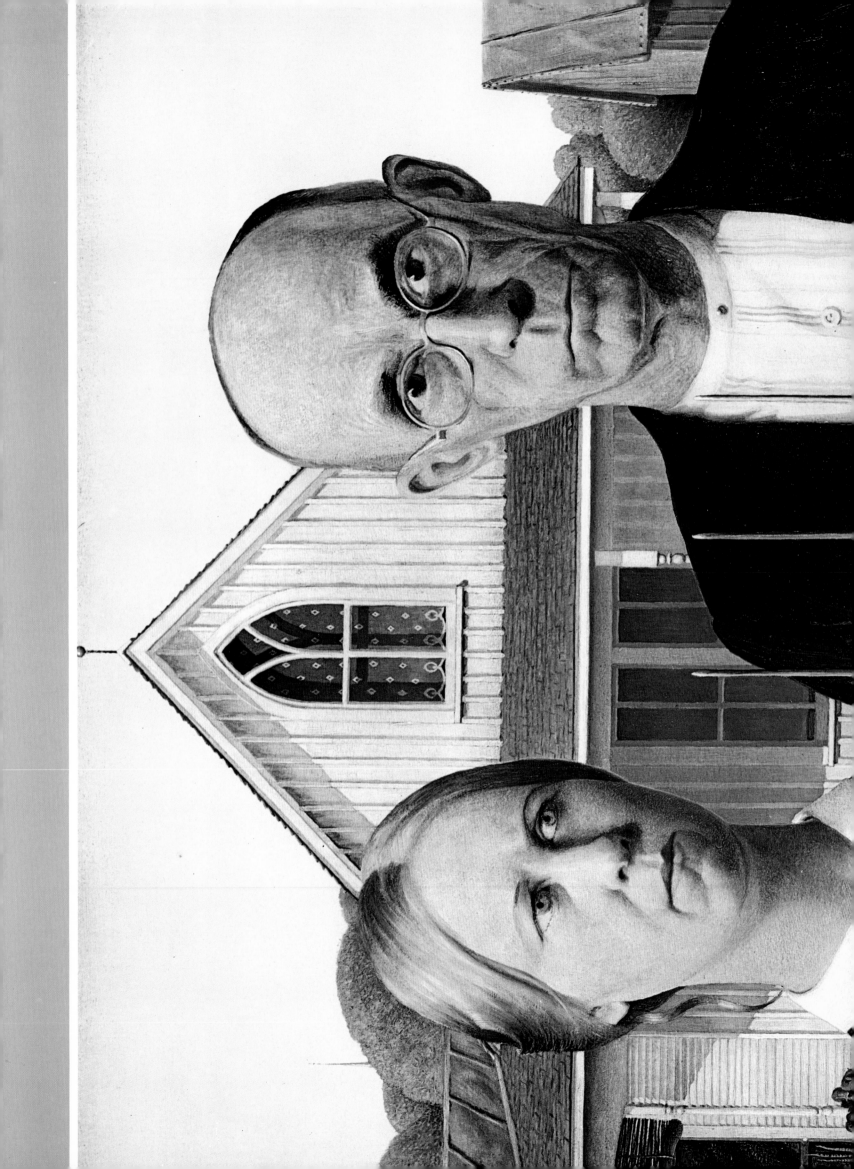

Grant Wood: *American Gothic.* 75·9 × 63·2cm

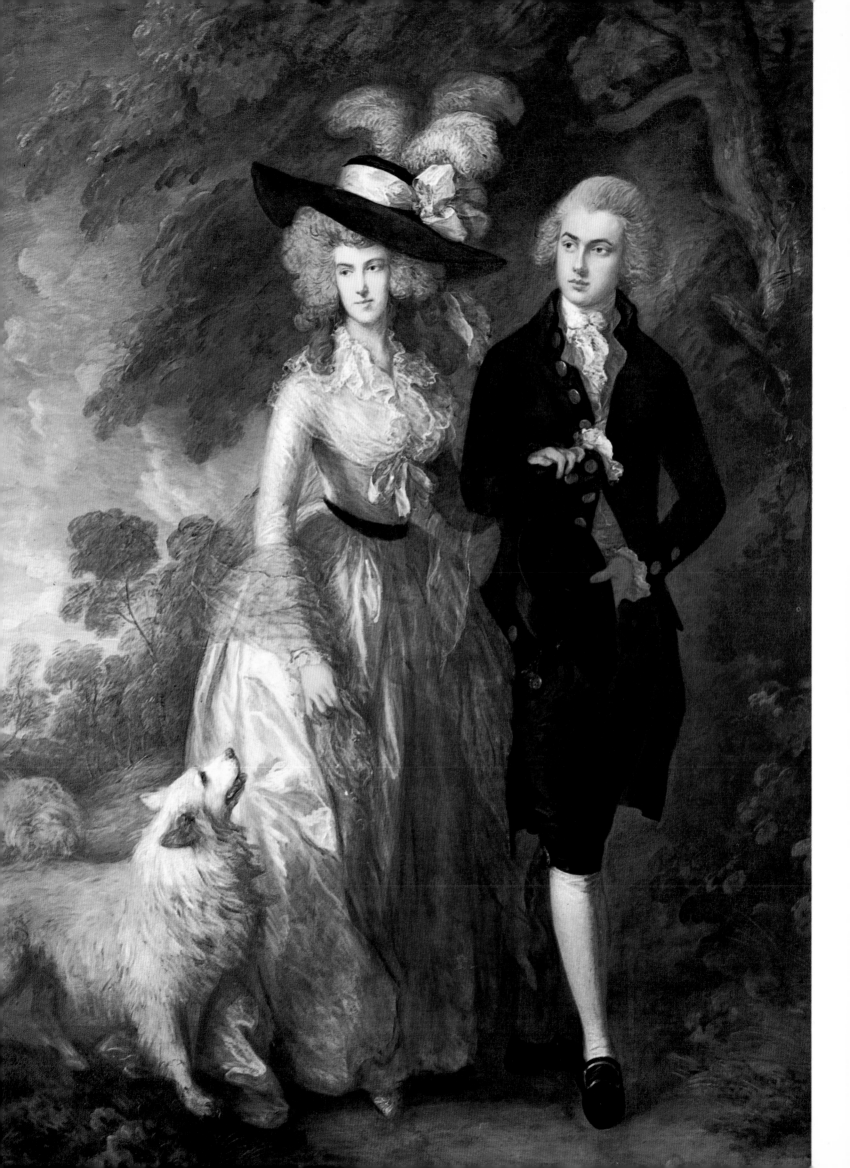

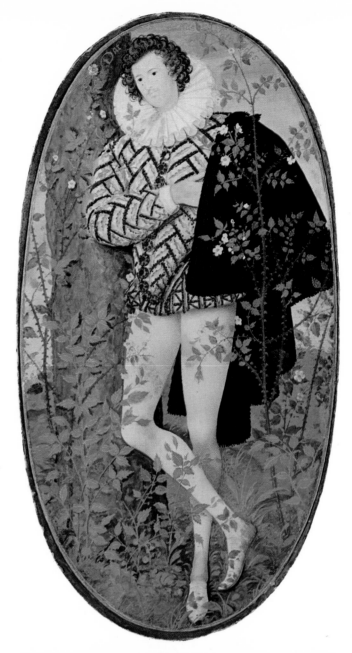

giver. This is the function which became above all the province of the portrait miniature. The painting of miniatures flourished between the early sixteenth century and the mid-nineteenth century, when their role was usurped by photography. The larger type of miniature, in a rectangular format, could be used to furnish desks and mantelpieces, but most commonly the miniature was worn as jewellery. It was incorporated into rings, brooches and bracelets, and, most

Dürer: *Self-portrait*, 56 × 44cm, 1493

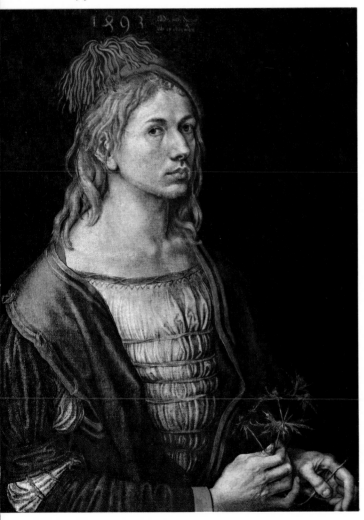

appropriately, into lockets kept near the wearer's heart. The favourite format was the oval. This is both decorative as personal adornment and comfortable to hold in the palm of the hand; background is reduced and the resulting concentration on the face, itself roughly oval in form, suggests intimacy. It is often for this latter reason that portrait paintings on a larger scale are also made in an oval shape. Hoppner's *Mrs Williams*, for example, gives the impression of a magnified miniature. Eye contact is of course of great importance in love-making, and the sitter normally looks

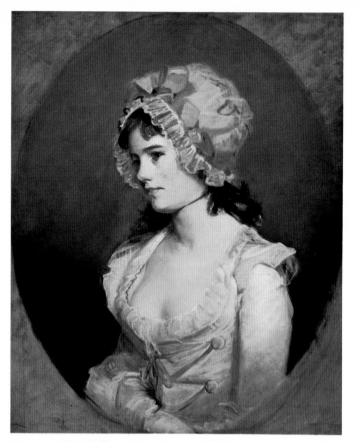

Hoppner: *Mrs Williams.* 74 × 61 cm, c.1790

directly out of the miniature. This aspect was taken to an extreme in the early part of the last century with the vogue for 'eye-miniatures' which showed only that part of the beloved's face.

* * *

Portraiture has traditionally been regarded as an inferior kind of art. The nineteenth-century critic, Vernon Lee, for example, wrote of it as 'a curious bastard of art sprung on the one side from a desire which is not artistic, nay, if any-

Courbet: *The Studio of the Painter. (A real allegory summing up seven years of my artistic life),* 359 × 598cm, 1855

Like Reynolds, Courbet mixes portraiture and allegory. But whereas for Reynolds this is a way of elevating the portrait, Courbet uses it to bring allegory down to earth. Each of the figures in his *Studio* is an actual person who stands for some social or political phenomenon, which the artist felt was relevant to him and his art. Broadly speaking, bad things are represented by the people on the left and good ones by those on the right. In the centre Courbet himself personifies Genius, admired by Youth (the boy) and Beauty (the nude).

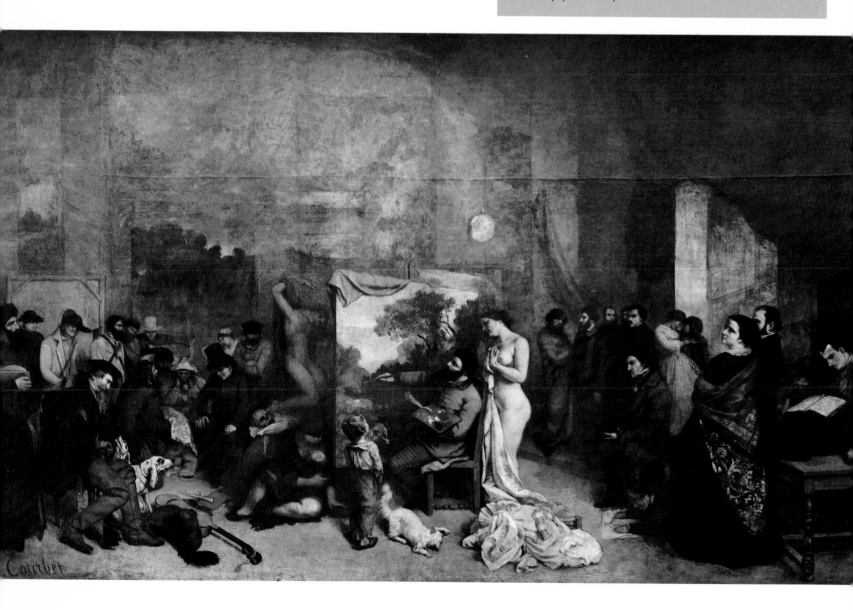

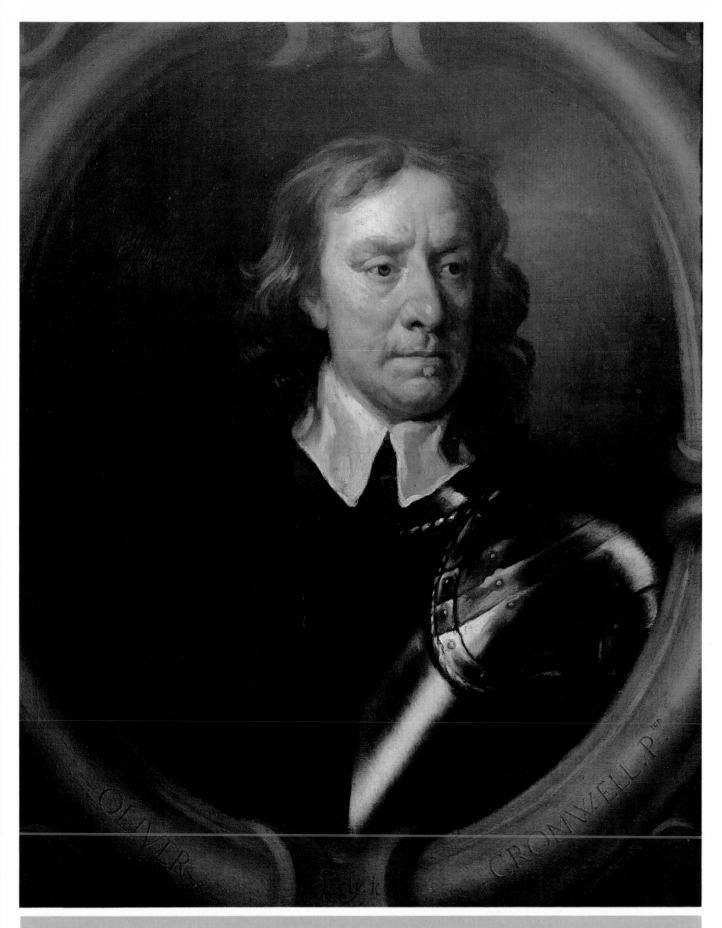

Lely: *Oliver Cromwell*, 76× 63cm, 1654

Cromwell's order to Lely to paint him 'warts and everything' was the outcome of his Puritanism. Having a portrait made smacked of the sin of Pride – flattery was unthinkable. Nevertheless, the artist does seem to have got away with suppressing one of the warts; another portrait of Cromwell shows a wart quite definitely in the corner of the right eye by the nose. The oval form of miniatures and works such as Hoppner's *Mrs Williams* gives a feeling of intimacy; here the effect is the opposite. The use of architectural surrounds of this kind can be traced back to the Roman practice of displaying commemorative busts in circular or oval niches in walls.

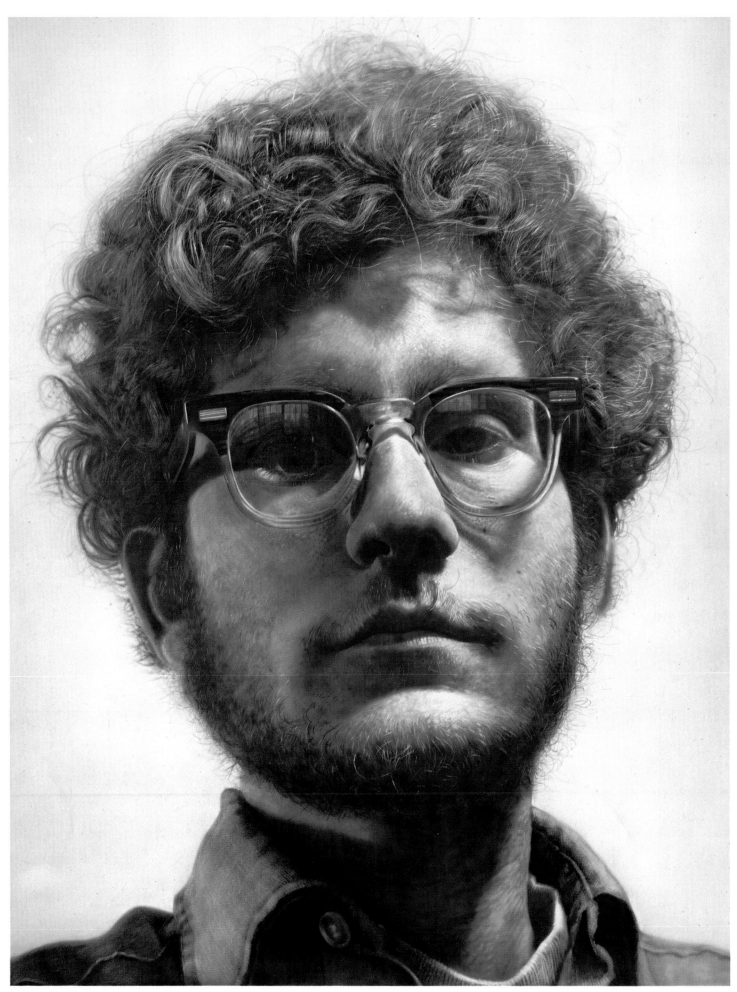

Chuck Close: *Frank*, 1969

thing, opposed to the whole nature and function of art: the desire for the mere likeness of an individual'. It is indeed sometimes the case that 'mere likeness' is all that is called for or intended. Oliver Cromwell is said to have constrained his portraitist Lily 'to paint my picture truly like me, & not Flatter me at all but remark all these ruffness, pimples warts & everything as you see me; otherwise I never will pay a farthing for it.' The contemporary American artist, Chuck Close, has deliberately eliminated the role of artistic licence in a way of which Cromwell would have approved. Close's large-scale paintings, *Frank* for instance, are scrupulously copied from inexpressive passport-type photographs. 'There is no invention at all,' he has said, 'I simply accept the subject-matter.' The kind of art theory against which Close is reacting is that in which the artist is seen as one who goes beyond mere appearances and expresses some higher truth. In this view, the way individual things or people happen to look is artistically of little account. Michelangelo's tomb sculptures in the Medici Chapel in Florence, for example, are not likenesses of the men whom they ostensibly represent, but perfect human forms without distinguishing features: that is, they are 'ideal'. When this aspect was criticized, the artist retorted: 'What on earth will it matter in a thousand years' time what these men looked like?'

There are of course shades of opinion between the ex-

tremes represented by Close and Michelangelo. The views of Joshua Reynolds, for instance, were a compromise. He considered Michelangelo to be the greatest of all artists and the concept of the ideal to be the 'leading principle by which works of genius are conducted'. But no artist painting in eighteenth-century England as Reynolds was, could hope to make a living by working in the manner of Michelangelo.

Reynolds: *Three Ladies Adorning a Term of Hymen*, 234 × 290·5cm, 1774

If a portraitist is well versed in more elevated kinds of subject-matter he will, according to Reynolds, 'bring into the lower sphere of art a grandeur of composition and character, that will raise and ennoble his works far above their natural rank'. The three ladies here are the daughters of Sir William Montgomery, Barbara, Elizabeth and Anne. The statue on a tall base, or 'term', represents Hymen, god of Wedlock. Hence the two daughters who are married are shown near it, and their unmarried sister is still gathering flowers for the garland. This allegorical conception was inspired by two themes from high art: that of 'Sacrifice to Hymen', treated for example by the seventeenth-century classicist Poussin, and that of 'Nature Attired by the Three Graces' which was painted by Rubens and other artists.

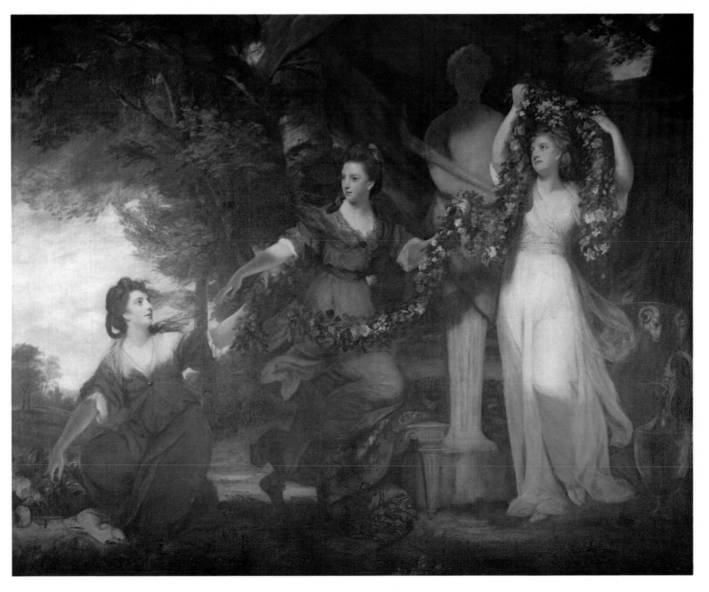

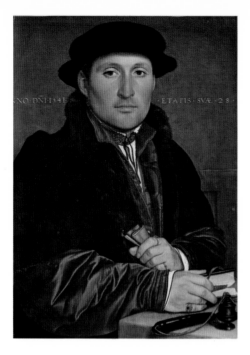

Holbein the Younger: *Young Merchant*, 46·5 × 34·5cm, 1541

The demand was for lifelike portraiture. Reynolds, therefore, advocated idealizing faces as much as is possible without completely losing the likeness, dressing sitters in classical-looking costumes, and even introducing mythological or allegorical overtones. It was under Reynolds' influence that John Hoppner used to begin his portraits by painting an ideal head. He then gradually added in the sitter's characteristics until bystanders said they could see a likeness coming, at which point he immediately stopped.

The ideal which Reynolds and Hoppner mingled with the features of their sitters was universal; it did not, by definition, vary from individual to individual. But there is another sense in which virtually all portraiture, not just the kind practised by these artists, can be called ideal. The philosopher Edmund Burke said, 'a portrait is the ideal of a man, not of men in general'. A man has more than one appearance. His looks change in different lighting conditions and viewpoints, and, of course, his facial expression is constantly altering according to his mood. This is why a life- or death-mask is never a

American School: *Henry Gibbs*, 72·5 × 62cm, 18th century

good likeness: it registers the contours of the face under very particular circumstances. In real life we form a general impression of what someone looks like over a period of time. We expect a portrait to approximate to this impression. And when we consider it a successful likeness of the person we commonly say 'it is more like him than he is himself': that is, it conveys more of the *look* of the person than would be gained from seeing him at any specific moment.

Another way in which a portrait can be 'the ideal of a man' is by providing biographical information which will not be displayed at any specific moment. Most obviously,

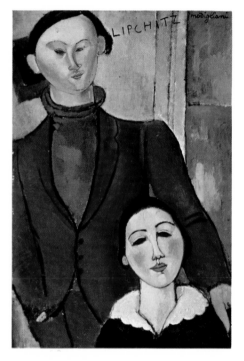

Modigliani: *Jacques Lipchitz and his Wife*, 80 × 53·5cm, 1917

details can be given in inscriptions. The commonest of all is the following: 'Anno Domini (followed by a date). Anno Aetatis Suae (followed by a figure)', which means 'In the year of Our Lord . . . In the year when he (or she) was aged . . .' This appears in many abbreviations and variations. Holbein's *Young Merchant*, for instance, is inscribed 'Anno· Dni·1541·etatis·suae·28'. The sitter's name is included less frequently for the obvious reason that during his lifetime his identity should be recognized from the likeness alone. Inscriptions make the spectator aware of a painting as a flat surface and thus impair the three-dimensional effect. This matters little with works such as Modigliani's *Jacques Lipchitz and his Wife* which are not intended to be illusionistic. When

Pisanello: *Ginevra d'Este*, 43× 30cm, early 1430s

The shrub in a two-handled vase which we see on the lady's surcoat was the insignia, or *impresa* of the d'Este family, and the sprig of juniper indicates that her forename was Ginevra: the word for juniper is *ginepro* in Italian and more closely, *genevra* in Romance dialects. Leonardo includes a bush of juniper behind the sitter's head in his *Ginevra de' Benci*, and there is also a wreath of it painted on the back of the panel. This is in fact cut off at the bottom, suggesting that the work was originally deeper and so may have shown the hands.

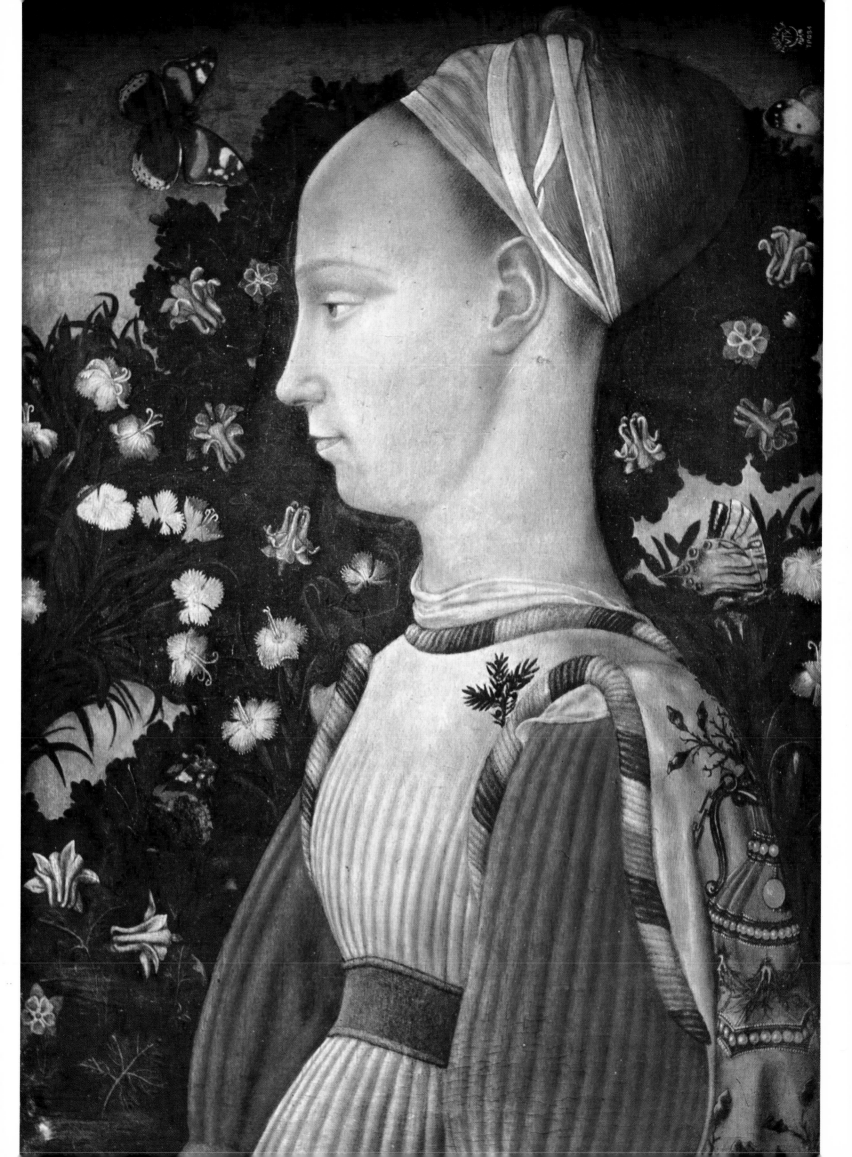

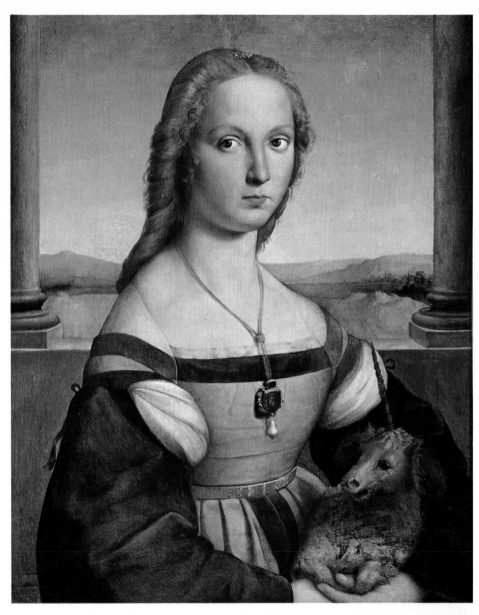

Raphael(?): *Young Woman with a Unicorn*, 65 × 51cm, 1505–6
OPPOSITE
Ingres: *Mademoiselle Rivière* 100 × 70cm, 1805

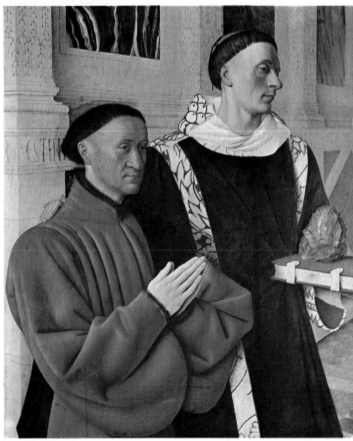

Fouquet: *Estienne Chevalier and St Stephen* (detail of the *Melun Diptych*), 93 × 85cm, c.1450

illusion is the intention, the problem is often solved by smuggling inscriptions into the setting of the portrait. The sitter, for example, may be shown holding a letter clearly marked with his name, as in the portrait of Henry Gibbs here. The painter of this work has clearly not, however, attemped to pretend that the heraldic shields are anywhere except on the picture's surface. In his *Pompejus Occo*, Dirk Jacobsz takes an alternative approach, showing his sitter's coat of arms hanging in a nearby tree.

On the left panel of Fouquet's *Melun Diptych* we see the donor Estienne Chevalier with his patron saint, and the name which they share is displayed in relief on the wall behind them. St. Stephen (Estienne, in old French) suffered martyrdom by stoning, and hence a stone is his trademark, or 'attribute'. Objects and sometimes animals are used in a comparable way in portraits. In fifteenth-century Italy, for example, a bush or sprig of juniper was invariably shown as the attribute of girls called Ginevra. Attributes need not simply refer to the sitter's name. In the *Young Woman with a Unicorn*, possibly by Raphael, the fantastic creature is a symbol of chastity. A less explicit use of animal imagery can be seen in Ingres' *Mademoiselle Rivière*. As in the *Mona Lisa*, of which the work is deliberately reminiscent, a river is shown in the background landscape. This is a play on the sitter's surname, and it may have suggested her likeness, with her elongated neck, her white and yellow garments, and the wing-like forms of her boa, to a swan.

32

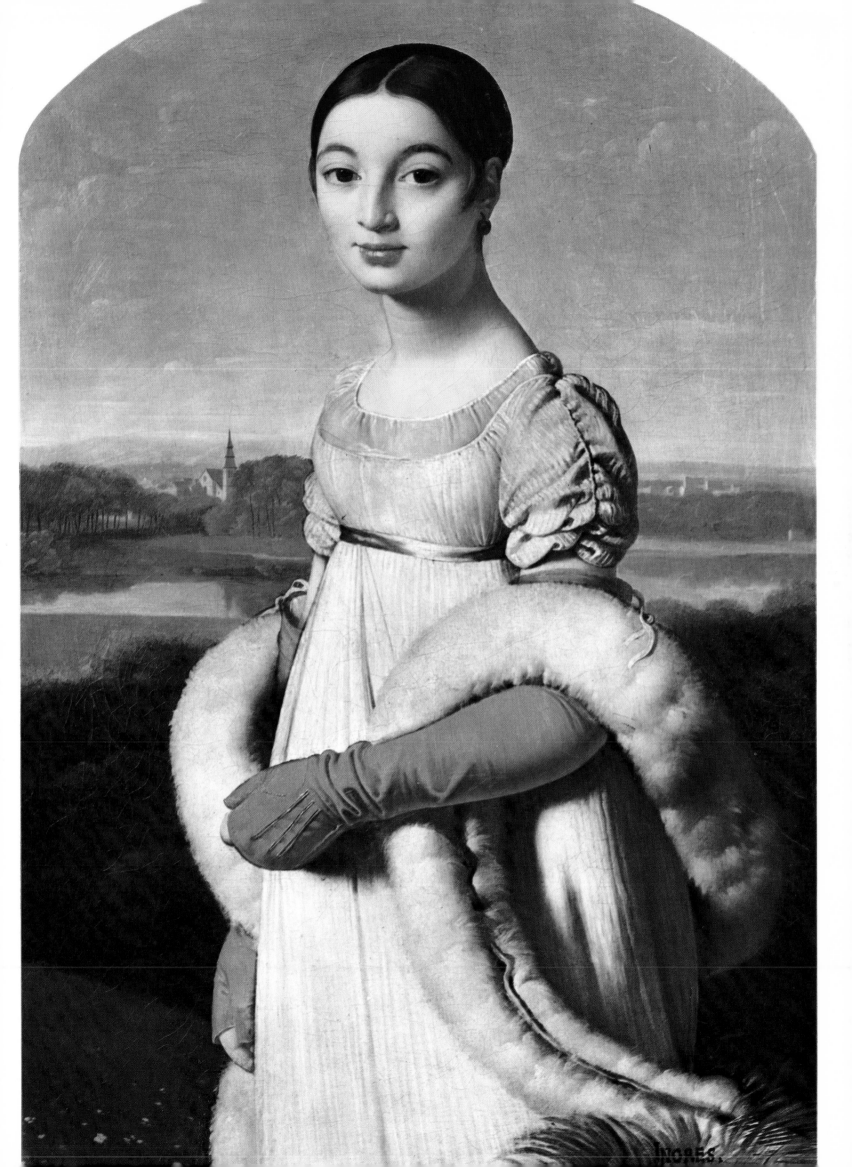

Portrait Painting: **Leonardo**

Fine horsemanship is traditionally a mark of aristocratic education. And the horse is an age-old symbol of power. When Napoleon instructed the artist David to paint him 'calm on a fiery steed', he brought together these two ideas in a way which has a bearing on all equestrian portraiture: the rider controls a tremendous force, but nonchalantly and with grace. The equestrian portrait is an image of political and military command. Its *locus classicus* in painting is

Velazquez: *Count-Duke de Olivares*, 313×239cm, 1634

Philip IV took little active part in running Spain, and his Prime Minister Count-Duke de Olivares was effectively the most powerful man in the country. This work was painted as one of a series of equestrian portraits to decorate a room in the new Palace of Buen Retiro, Madrid. Olivares is shown as if giving the order to charge; the baton he holds is a traditional sign of military command. Ranks of enemy forces are visible in the landscape background, literally crushed under his heel. In fact the Prime Minister held no position in the army, and had certainly never been into battle. Titian's *Charles V* is unusual in being connected with actual fighting; for the most part equestrian portraits have a purely symbolic meaning as images of power.

Leonardo da Vinci: *Ginevra de' Benci*, 38 × 36·5cm, c.1474

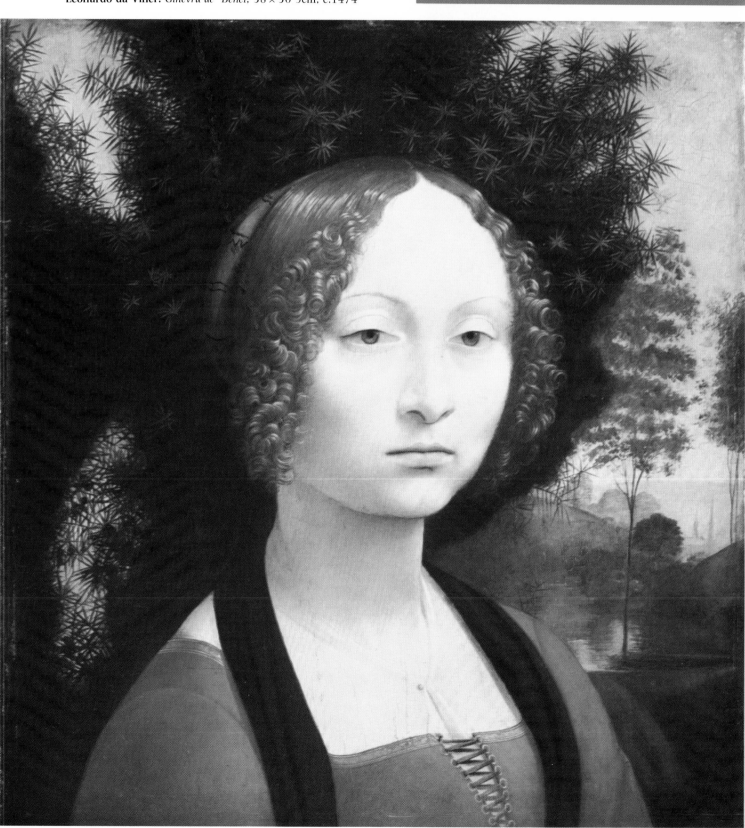

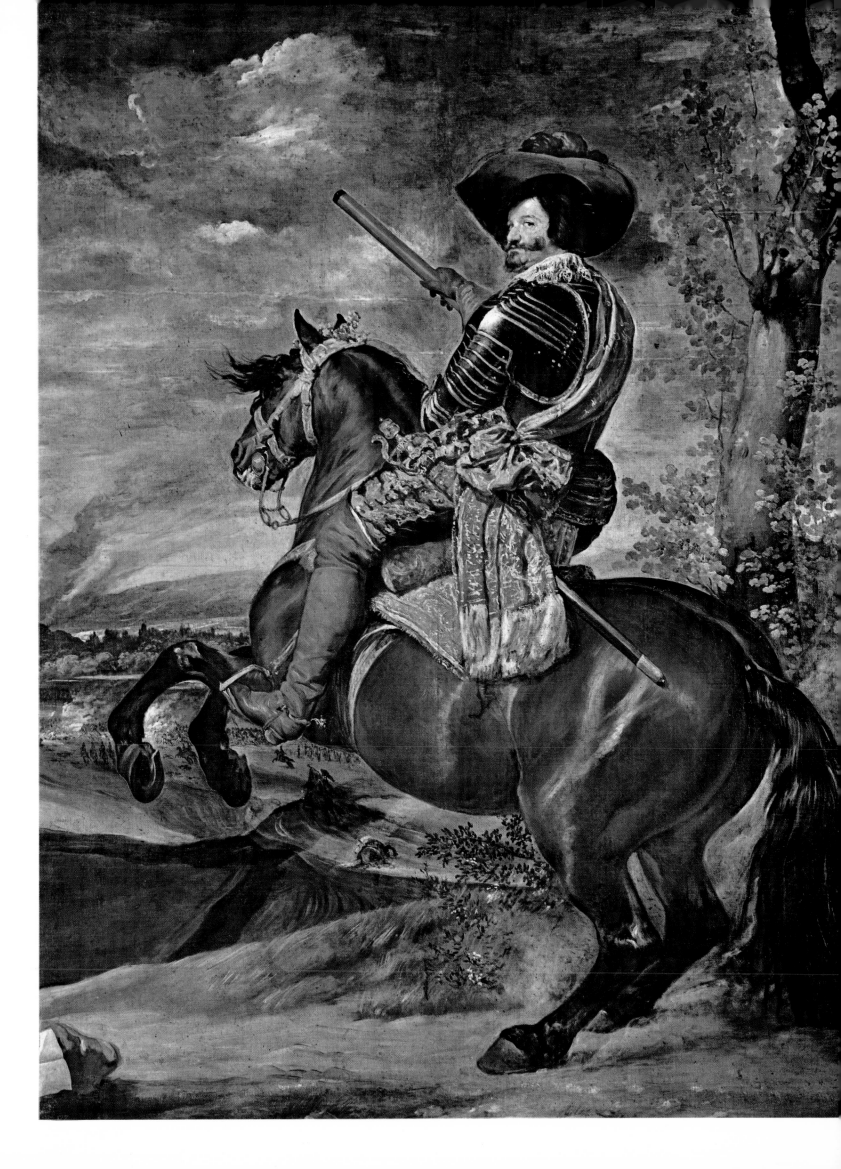

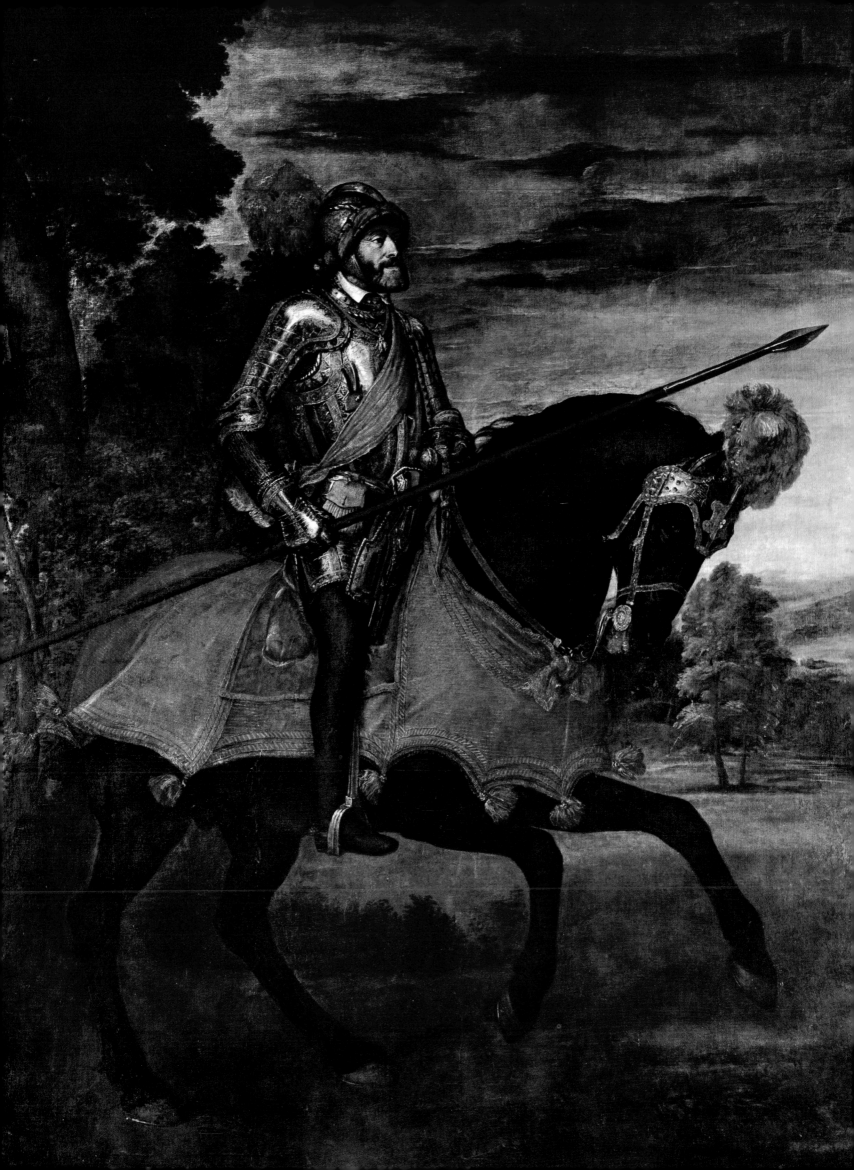

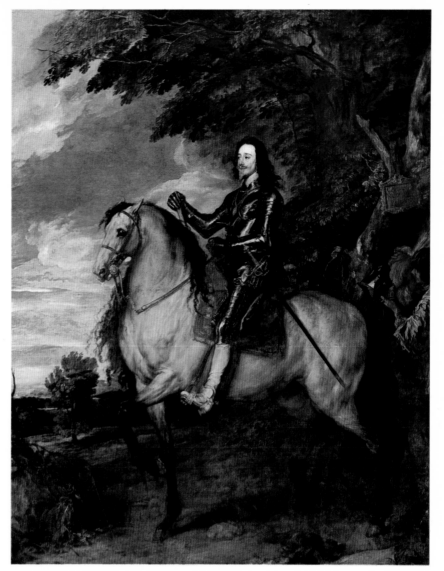

Titian's *Charles V*. The emperor is shown as he appeared at the battle of Mühlberg, mounted on the same horse and wearing the same gold-chased armour. Charles' victory at Mühlberg was a triumph for Catholicism against the forces of the Protestant Reformation. His portrait is appropriately reminiscent of images of the Christian Knight – Dürer's famous *Knight, Death and the Devil* for instance – and more specifically of St. George, patron of all Christian warriors. Just as St. George overcomes the dragon, symbol of evil, so Charles appears to be chasing away the dark clouds of Protestantism.

Animals in portraits tend to bear a curious, and often telling, resemblance to the humans with whom they are shown. There is a correspondence, for example, between the long sensitive face of Charles I in the equestrian portrait of him by Van Dyck, and that of his horse. It is altogether a more decorative and refined-looking animal than the one ridden by Charles V, a horse for processions rather than battles. The king wears armour and on his chest is a badge actually representing St. George – the insignia of the Order of the Garter – but the emphasis here is all on stateliness and dignity, not military prowess.

The attributes in Holbein's *Georg Gisze* are articles of writing equipment: quill pens, inkstands, seals, sealing-wax, a signet ring, and a sand caster. Along with the ledgers and business letters, these relate to the sitter's occupation. He was one of the 'Merchants of the Steelyard', several of whom were painted by Holbein. (*Young Merchant* in Vienna is probably another.) The Merchants were Germans living in England – the letter in the sitter's hand is addressed 'to my brother Georg Gisze in London' – and so correspondence was presumably important for personal as well as business pur-

Van Dyck: *Charles I*, 365 × 289cm, c.1638–9

poses. But might there not also be some ulterior motive in the choice of objects and their disposition: the balance, for instance, dangling near an inscription which reads 'Nulla sine merore voluptas' ('No pleasure without sorrow')? The enigmatic flavour is even stronger in the portraits of the Venetian painter Lorenzo Lotto. His *Young Man in his Study* contains much that is symbolic-looking but whose meaning is elusive: the lute and the hunting-horn to the left and the

Holbein the Younger: *Georg Gisze*, 96 × 87·5cm, 1532

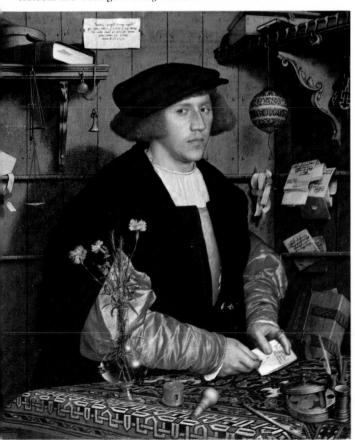

Lotto: *Young Man in his Study*, 98 × 111cm, c.1524

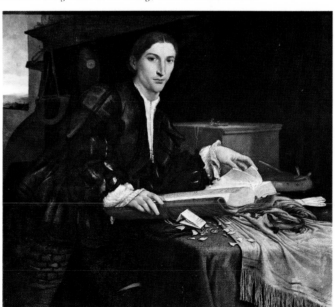

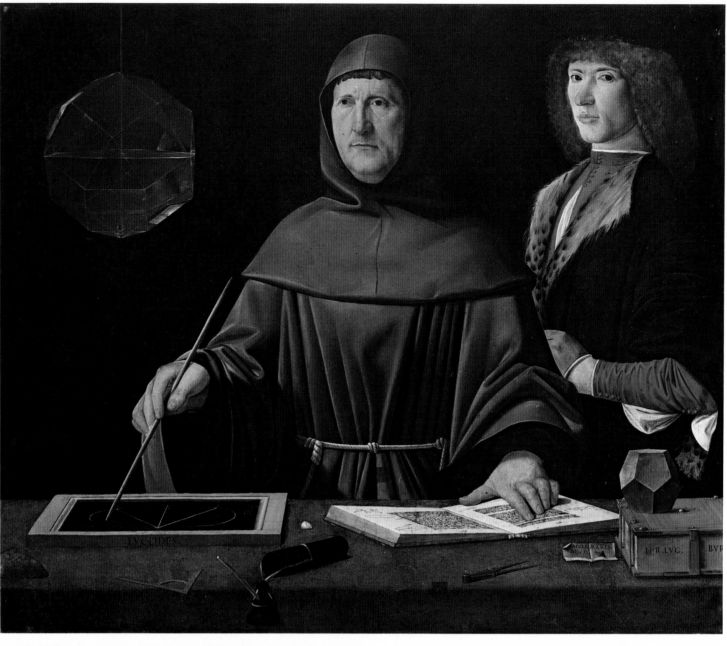

'Jacob. Bar.': *Fra Luca Pacioli,* 99×120cm, 1495

A small piece of paper in a picture bearing the artist's signature is known as a *cartellino.* Bellini's name, for example, is introduced in this way in his portrait, *Doge Loredano.* Here the *cartellino* in the lower right corner is inscribed 'Jacob. Bar.', an abbreviation which has not yet been satisfactorily identified with the name of any known artist. Other aspects of the work are easier to interpret. Pacioli was a monk and mathematician. The drawing on the blackboard illustrates the construction of the first regular solid of Euclidian geometry, the pyramid, or tetrahedron; on the book to the right we see a dodecahedron, the fifth regular solid, and suspended in the upper left corner an icosahexahedron, a regular solid with twenty-six sides. The book on which Pacioli's hand rests is thus supposedly by Euclid. The one on the extreme right is recognizable as his own *Summa de Arithmetica.* The young man standing immediately behind this work is Guidobaldo, Duke of Urbino, the patron to whom it is dedicated. Like the woman in Rembrandt's portrait of Anslo, his presence suggests Pacioli's role as a teacher. The geometrical forms set the keynote of the whole picture; Pacioli seems to inhabit a world which conforms rigorously to mathematical concepts.

seascape beyond, and the rose petals scattered on the table-cloth. There is undoubtedly more symbolism in portraits than we recognize. Much of it had a private or esoteric significance which has long been forgotten, and probably some is connected with membership of secret societies and was never intended to be understood generally, even in the sitter's lifetime.

Like Titian's *Charles V,* Holbein's portrait of the theologian Erasmus quotes from religious images with which contemporaries were much more familiar than we are. The work recalls those representations of the gospel-writers which appeared on the opening pages of illuminated manuscripts of their books. This is apposite since Erasmus is actually shown writing the first words of his own *Commentary on the Gospel of St. Mark.* The lions in the pattern of the background hanging probably also allude to St. Mark, whose attribute is a lion. The novelist and critic Zola is similarly shown with one of his own works in the portrait of him by Manet. The blue booklet visible immediately behind the quill pen on the desk is Zola's defence of the artist, in gratitude for which the portrait was painted. The selection of objects surrounding him amounts to a manifesto of Manet's artistic

Holbein the Younger: *Erasmus,* 42 × 32cm, 1523

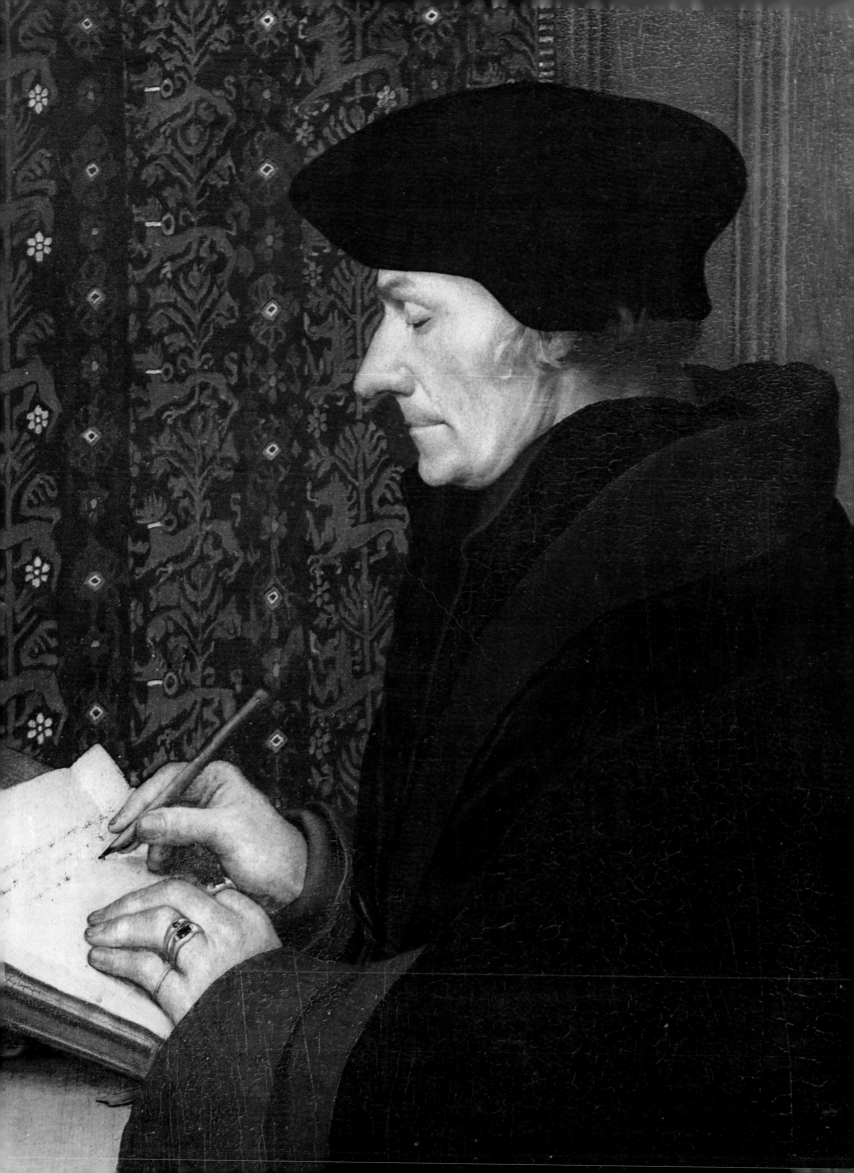

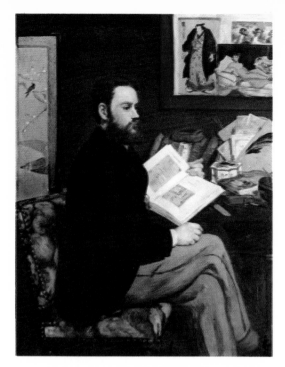

Manet: *Émile Zola,* 146 × 114cm, 1868

a medal struck which bore his head and an inscription to the effect that his *true* portrait is given in his works. The poet Vondel echoed this thought in his lines on an etching by Rembrandt which showed the preacher Cornelis Claesz. Anslo: 'Rembrandt should paint the voice of Cornelius, his outward appearance is the least of him; the invisible can only be known through the ears. He who wishes to see Anslo must hear him.' The artist seems to have been taken up the challenge in his painted portrait of Anslo. We look up at him as if he is on a speaker's platform and we are among his audience. The largest book on the table is presumably the Bible, which reminds us that the Mennonite sect, of which Anslo was the leading preacher, placed a strong emphasis on the importance of the Scriptures. But the point of the picture lies in the way in which the woman gazes fixedly at the single candle which, as we can tell from the trail of smoke above it, has just gone out. This common symbol of *vanitas* – the transience of human life – is a visualization of her thoughts. If Rembrandt has not literally painted the voice of Anslo, at least he has painted its effect.

David's *Napoleon in his Study* is another portrait which tells a story. As the Emperor himself appreciatively observed: 'You have understood me David. By night I work for the welfare of my subjects and by day for their glory.' The clock shows 4.13 a.m. Napoleon is unshaven and his clothes are wrinkled. On the table is the manuscript of his legal

principles, a kind of visual supplement to the booklet. The screen, the inkwell and the coloured print on the back wall testify to the painter's enthusiasm for Japanese art. Next to the print is a reproduction of a painting by Velasquez, whom Manet admired, and lying symbolically across both is a reproduction of his own *Olympia*. The attributes here are those of the artist not the sitter.

Some years before Holbein's portrait of him, Erasmus had

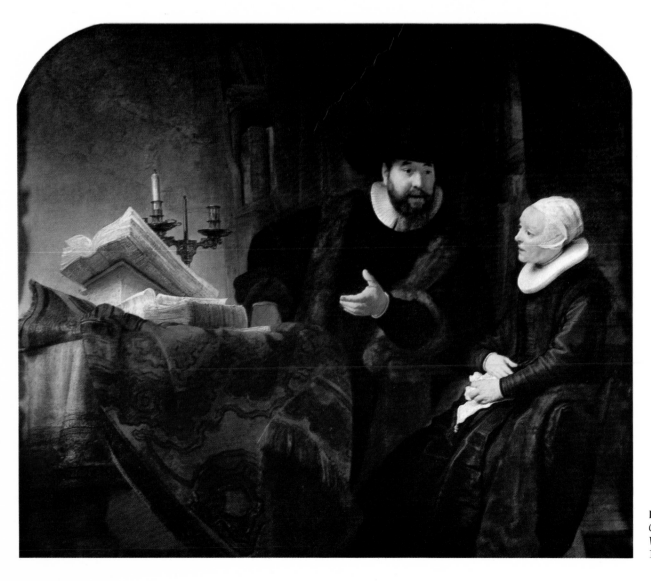

Rembrandt: *Cornelius Claesz. Anslo and a Woman,* 172 × 209cm, 1641

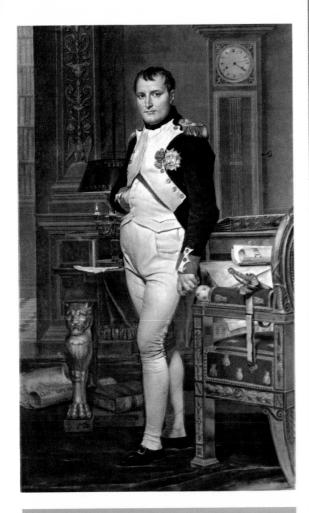

David: *Napoleon in his Study*,
204×125cm, 1812

Portraits of great men have generally been
thought to exercise a magical influence.
It is said, for example, that the young
Julius Caesar was inspired by seeing a
statue of Alexander the Great. Napoleon
had this power in mind — as well as a
reluctance to waste time sitting — when
he said to David: 'Who cares if portraits of
great men are good likenesses? What
counts is that their genius should come
out.' *Napoleon in his Study* was not
commissioned by the Emperor himself but
by an eccentric Scot, the Duke of
Hamilton, who lived in Rome and was
attempting to build up a collection of
portraits of all the rulers of Europe. Under
the table in the picture is a copy of
Plutarch's *Parallel Lives*, a classical text
in which biographies are given in pairs
for the purpose of comparison: Caesar
and Alexander, for example, are grouped
together. The intention is clearly to imply
such a parallel between the illustrious
figures of antiquity and Napoleon.

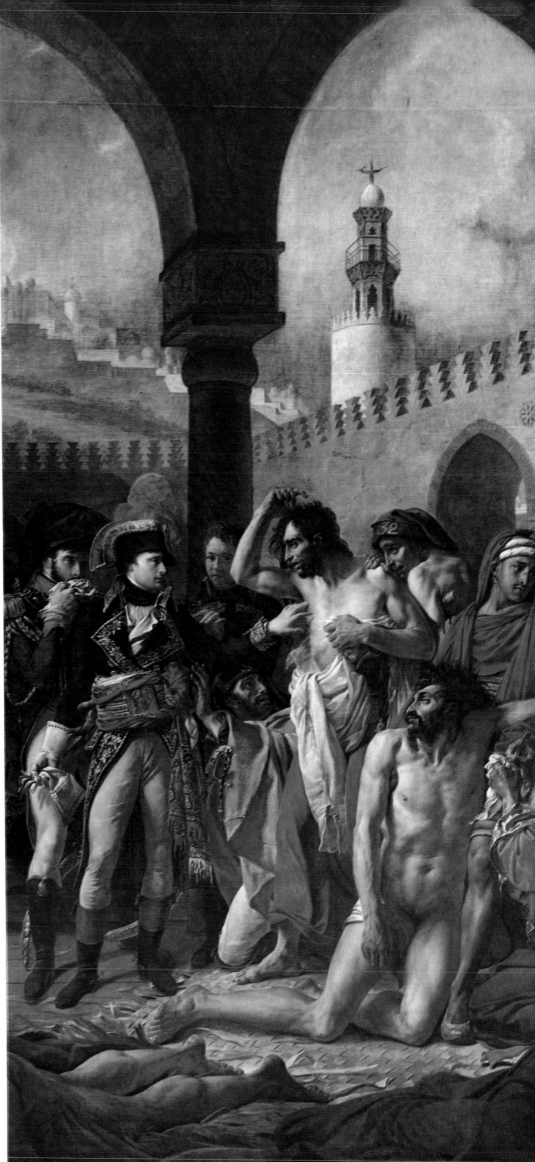

Gros: *Napoleon* (detail of *The Plague Hospital
at Jaffa*), 532 × 720cm (complete work), 1804

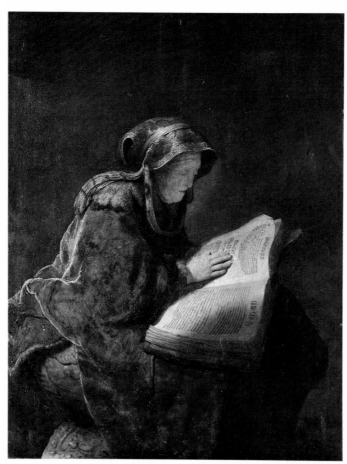

Rembrandt: *The Artist's Mother as an Old Testament Prophetess (Hannah?),* 60 × 48cm, 1631

Rembrandt: *The Artist's Wife as Artemesia,* 142 × 153cm, 1634

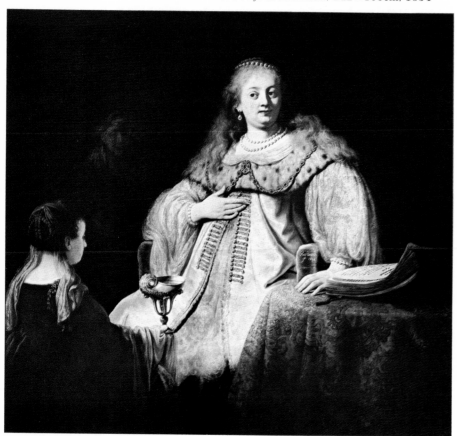

magnum opus, the 'Code Napoléon', on which he has been working all night. He has stopped only to put on his sword and go out to review his troops. *The Plague Hospital at Jaffa* presents a different aspect of the Napoleonic *persona*: courage. When bubonic plague broke out in the French army of occupation in Syria, Napoleon deliberately walked through a hospital to demonstrate to his soldiers that there was no basis for the fear of contagion which was making them panicky. This is the incident depicted in Gros' painting. We have seen how religious allusions give resonance to a portrait; they also make for powerful propaganda. The figure of Napoleon in *The Plague Hospital at Jaffa* conjures up associations with healer-saints like St. Roch as they are represented in earlier paintings. And the way in which he is fearlessly touching a plague-victim's sores also relates to the superstition that kings could cure scrofula ('the king's evil') by their semi-divine touch.

Some portraits present the sitter quite explicitly 'in character', as some historical, dramatic or mythological figure. Most obviously, actors and actresses are shown in favourite parts. Otherwise, the role adopted may be inspired by a costume worn at a fancy dress ball, or it may be chosen simply for its appropriateness. Diane de Poitiers, who largely controlled court patronage under Henry II of France, made herself the centre of an artistic cult in which she was identified with her namesake the goddess Diana. In the nude portrait of her in this role she is typically shown with a headdress in the form of a crescent and with a hound by her side; Diana is associated in mythology with the moon, and she is the goddess of hunting. Diane de Poitiers was a widow, and the exact nature of her relationship with the King was deliberately kept in doubt. This gave special point to the fact that the goddess Diana is also patroness of chastity. The portrait is titillatingly equivocal: inviting eyes are contradicted by a very cold shoulder.

Rembrandt painted his mother as an Old Testament figure, probably the prophetess Hannah, reading a Hebrew tome. And he was clearly fond of depicting his wife Saskia in fancy dress. The choice of role is at times ironic in intention – she is shown, for instance, as Bellona, goddess of war – but it is more often related to her role in real life as a wife. Thus she is portrayed as Flora for fertility, or as here, as Artemisia for devotion. Artemisia was a queen in classical times who married her own brother. When he died she had his ashes mixed into a drink and consumed them (the scene in the picture) and she herself died heartbroken a short time later. Is the work strictly a portrait of Saskia as Artemisia, or is it a picture of Artemisia for which Saskia was the model? In this case it is impossible to make such a distinction.

*　　　*　　　*

The rows of heads reproduced overleaf from Gentile Bellini's *Miracle of the True Cross* illustrates the tendency for portraits which are introduced into larger works to be in profile. This is a natural device for relating spectators near the edge of a picture to the central action. The dignitaries shown by Bellini have an ancestry in art which can be traced back to

Fontainebleau School: *Diane de Poitiers as Diana the Huntress,* 192 × 133cm, 1552–6

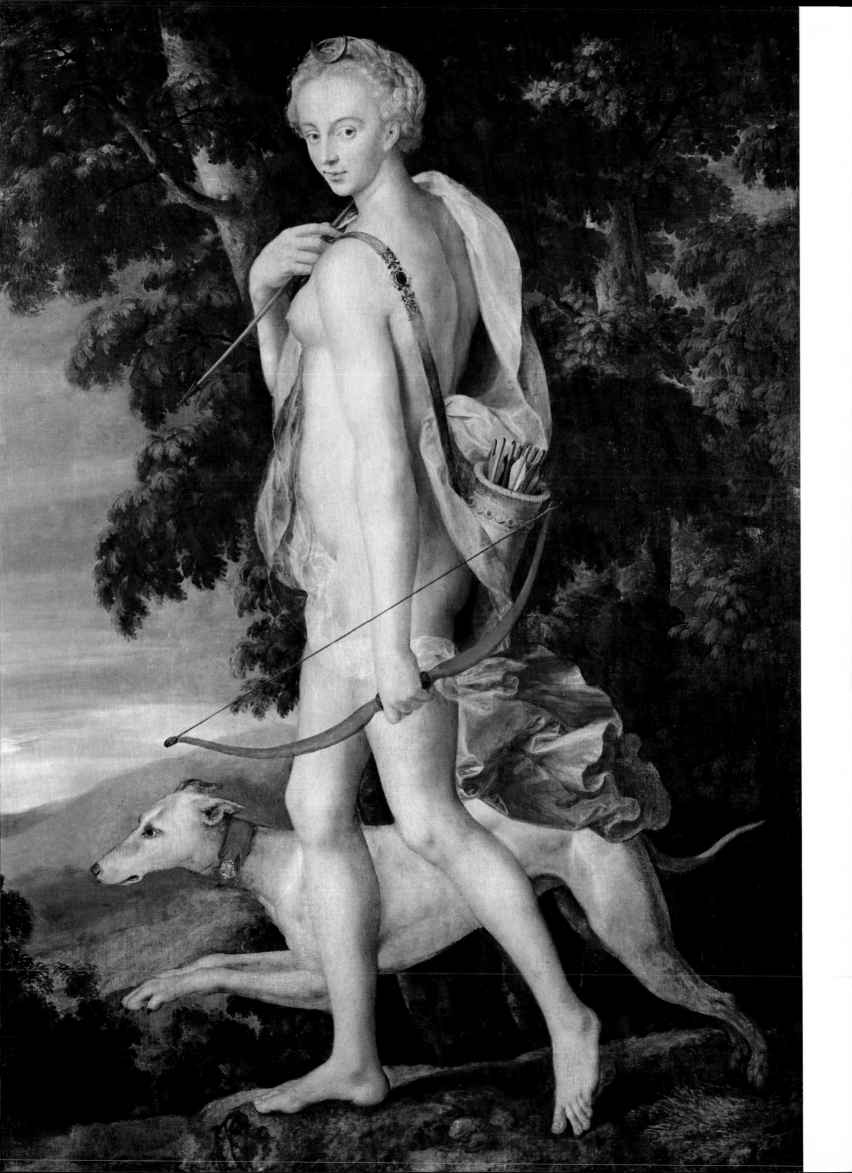

Bellini: *The Miracle of the*
True Cross (detail)

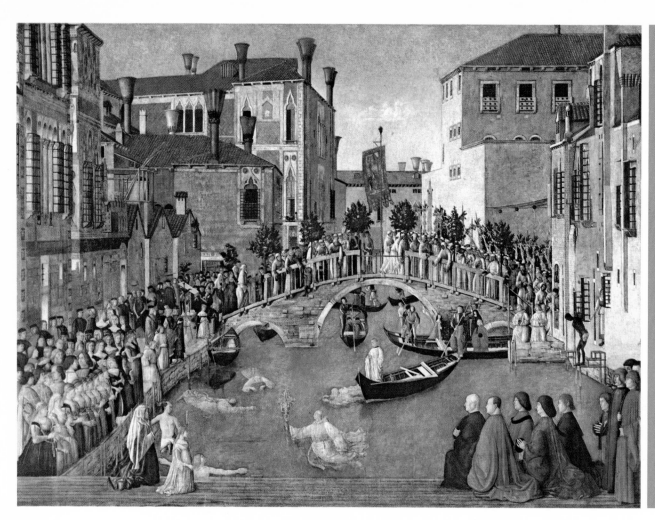

Gentile Bellini: *The Miracle of the True Cross*, 323× 430cm, 1500

In the process of being carried to the church of S. Lorenzo in Venice, the holy relic of the True Cross fell into a canal but was miraculously rescued by Andrea Vendramin. The event was recorded by Gentile Bellini in this decoration for the assembly room of the club of which Vendramin was the head official, the *Scuola di San Giovanni Evangelista*. The site is represented with high topographical accuracy, and the work contains likenesses of Vendramin and other members of the *scuola*.

the beginnings of portrait painting in the fourteenth century. Early donor portraits – for instance that of Robert of Anjou by Simone Martini – also normally give a profile view of the donor's face. The way in which the portrait emancipated itself from the status of an incidental in other kinds of painting is difficult to pin down. The development of altarpieces which showed the donor and the object of his devotion on separate panels may, for example, have played an important part in the transition to complete independence. The profile, however, seems to have been the starting point.

According to the first-century writer Pliny, the very first painting was a profile portrait made by tracing the outline of a man's shadow on a wall. The historical importance attached to the profile by Pliny, along with its sheer simplicity, has made this kind of portraiture especially popular

at times when men have felt a desire to get back to the purity of classical art. Moreover, precedents have always been available in the shape of the heads on Roman coins. The rise of silhouette portraits, in which black card is cut with scissors in the form of the sitter's profile, was an expression of 'neo-classical' taste in the later part of the eighteenth century. Wedgwood portrait medallions, which were popular in the same period, similarly bore profile heads. The classical associations of the form also lay behind the widespread use of the profile in fifteenth-century Italy. Works such as Pollaiuolo's *Portrait of a Woman* and the famous portraits of Federigo da Montefeltro and his wife by Piero della Francesca have a two-dimensional quality which is a natural outcome of the choice of viewpoint, since heads look flattest from the side. The profile is the most decorative kind of portrait, and

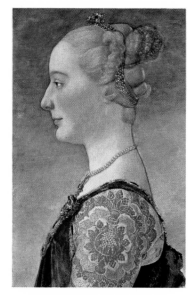

Pollaiuolo: *Portrait of a Woman*, 55 × 34·5cm, c.1475

Piero della Francesca: *Federigo da Montefeltro, Duke of Urbino*, 47×33cm, probably 1460s

Piero's two portraits deliberately imitate classical coins and medals: the heads are in profile, and on the reverse sides are allegorical images, featuring the Duke and Duchess riding in triumphal cars. The principle of showing couples with the man on the left and the woman on the right is not adhered to in this case. We might have expected it all the more because Roman coins almost invariably show the emperor's head facing to the right. The determining factor here was that the Duke had lost his right eye in jousting. There was a classical precedent for Piero's way of concealing this ugly feature of which both artist and sitter would have been conscious. Pliny records that Apelles, court painter to Alexander the Great, portrayed the celebrated general Antigonus in profile view for exactly the same reason.

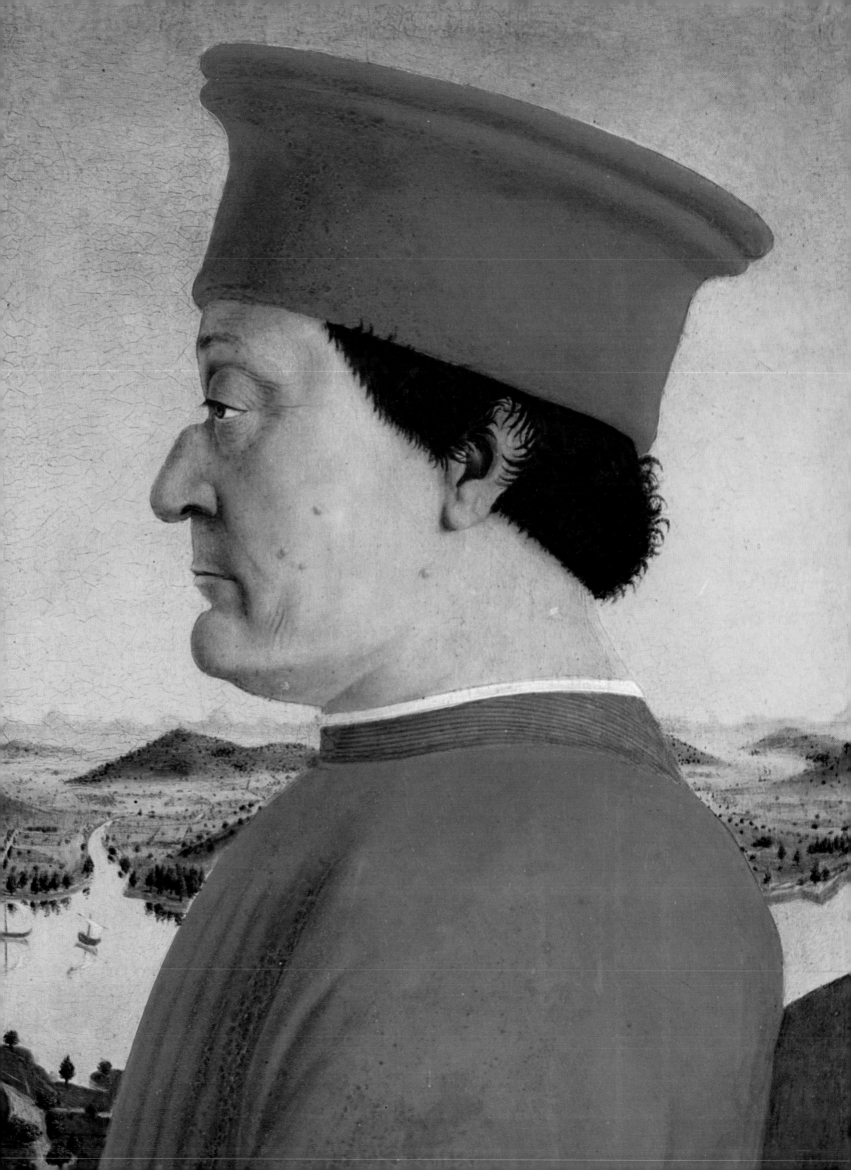

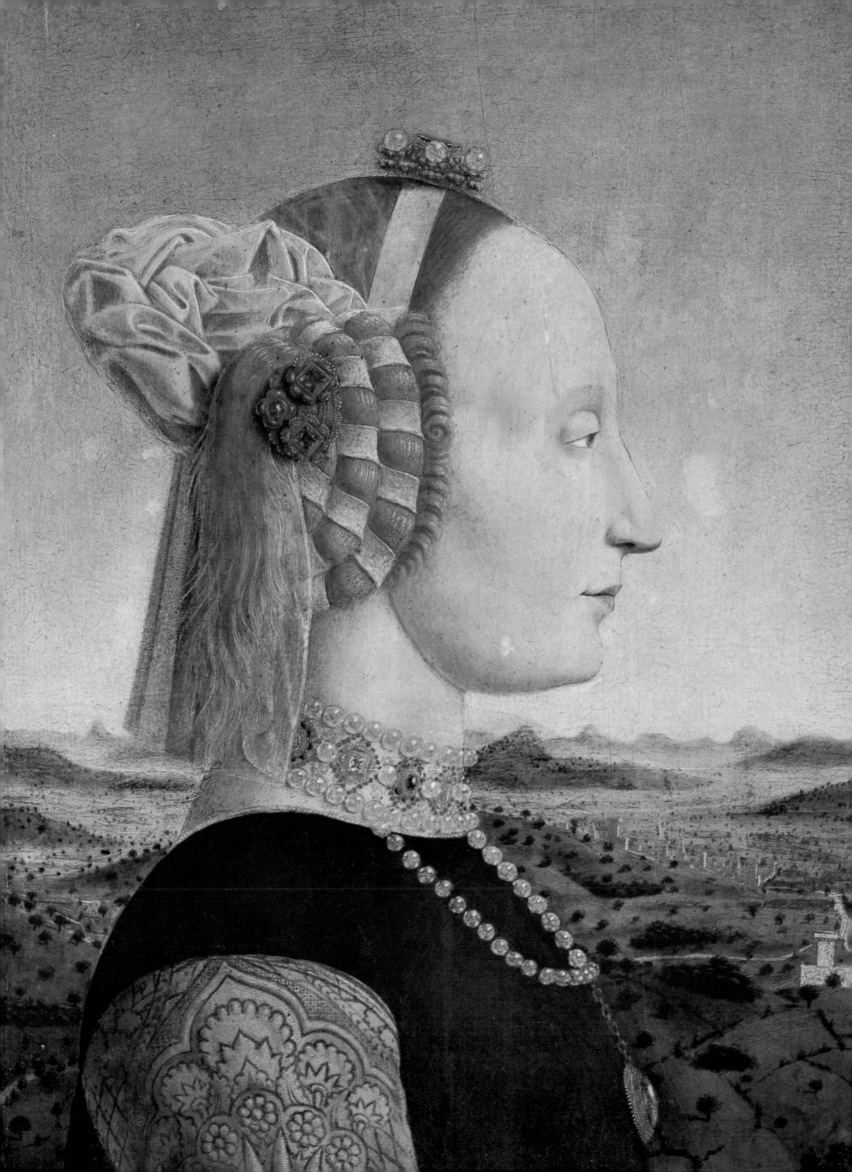

perhaps also the most flattering, but it is the least expressive.

Portraits from an angle between the profile view which shows half the face, and the directly frontal view, or full face, are said to be in 'three-quarter face', sometimes graphically called 'occhio e mezzo' ('eye and a half') in Italian. Because of the obvious projection of the nose in space, the head takes on a more three-dimensional appearance from this viewpoint. When an artist gives an impression of solidity to the head in a portrait, it is easier for us to forget that we are merely looking at colours on a flat surface; and we can believe, or at least suspend our disbelief, in the living presence of the sitter. For this reason the mastery of the three-quarter face was a crucial development in the history of portraiture. It was largely the achievement of Netherlandish artists in the first half of the fifteenth century. They were assisted by their use of oil paint as opposed to fresco and tempera, the commonest techniques in Italy at this time, since oil is highly conducive to the effect of tangibility in the depiction of objects. In this medium Jan van Eyck, who made the greatest single contribution, established means of giving a portrait 'presence' which have served painters ever since. It was van Eyck who first introduced the idea of illuminating the far side of the sitter's head in three-quarter face, rather than the near side as is more obvious. The contours of the near side, of which we see more, are thereby emphasized or 'modelled' by shadows, and the illusion of depth is enhanced.

Van Eyck also developed the technique of suggesting a spatial setting for the head by placing an illusionistic ledge before it, on which the sitter sometimes even rests his hand. Bellini's *Doge Loredano* is a later example of this practice. Although there is no ledge, the sitter in van Eyck's *Giovanni Arnolfini* (the same man as in the *Arnolfini Marriage Portrait*) appears to be leaning on the bottom part of the frame, and his left sleeve sticks out towards us. By implying that the space in the portrait is continuous with the real space occu-

Piero della Francesca: *Battista Sforza, Duchess of Urbino.* 47 × 33cm, 1460s(?)

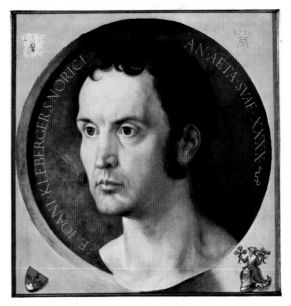

Dürer: *Johannes Kleberger.* 36·5 × 36·5cm, 1526

pied by the spectator, the artist encourages us to respond to the sitter as if he were there in front of us. This kind of illusionism is playfully carried to an extreme in Dürer's *Johannes Kleberger*, in which the apparently dismembered head floats towards us through a porthole. Another means of making a direct appeal to the spectator is to have the sitter look straight out at us, as if aware of our presence. This device again

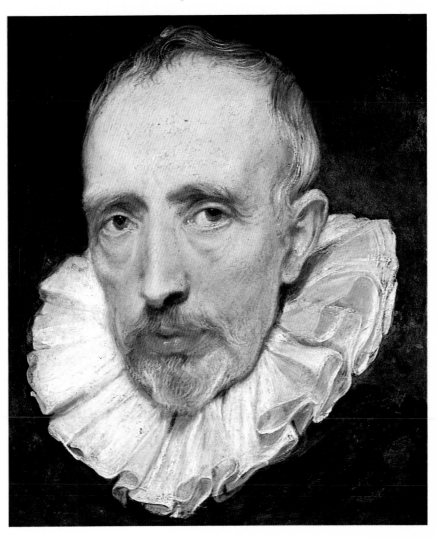

Van Dyck: *Cornelius van der Geest*, 37·5 × 32cm, c.1615–20

The early development of portraiture can be seen in terms of the conquest of the three-quarter face and the infusion of life into the head. Works such as this represent a culmination. The expression 'spitting image', a corruption of 'very spit and image', seems appropriate here. Thickly-painted white highlights in the eyes and on the lower lip give an exaggerated effect of moisture in the face, and hence of life, and the nostrils are flared to suggest breathing. El Greco's *Man with his Hand on his Heart* is an example of the portrait in full face, which is the least common of the three kinds of viewpoint. This is for the reasons that the head appears symmetrical from the front, it is difficult to draw the nose convincingly, and because the effect of direct confrontation with the spectator can be severe. El Greco's sitter has a divergent squint. His look is even more hypnotic because of its enigmatic quality, than that of others who look at us from their portraits. Slight squints are often introduced into portraits for this effect and also to suggest otherworldliness: the sitter's gaze is focused on the infinite.

49

seems to have been pioneered by van Eyck. Like other aspects of his style, it was imported into Italian art by Antonello da Messina in works such as the London National Gallery's *Portrait of a Man*. Infra-red photography has shown that the sitter in the latter portrait was originally looking to the left and that the way in which his eyes engage ours is the result of an alteration made in the process of painting. One can imagine how dramatically this intensified the effect of the work.

We often say that portraits such as those of Antonello are 'full of character'. It is impossible to resist the feeling that there is a personality behind the face, but can we really tell

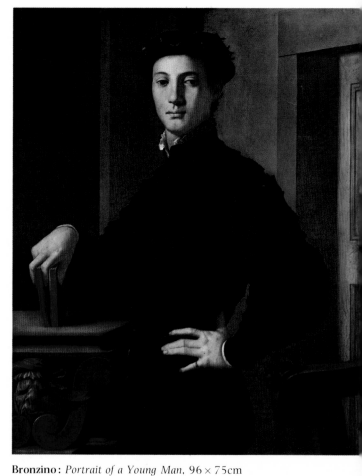

Bronzino: *Portrait of a Young Man.* 96 × 75cm

Velazquez: *Portrait of a Young Spaniard.* 89 × 69cm

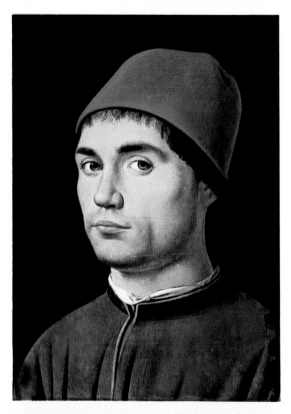

Antonello da Messina: *Portrait of a Man.* 35·5 × 25·5cm. c.1475

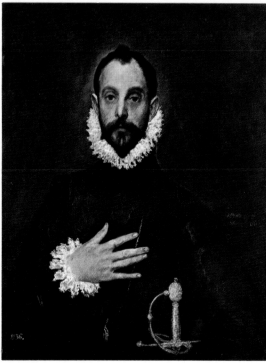

El Greco: *Portrait of a Man with his Hand on his Heart.* 81 × 86cm, c.1580

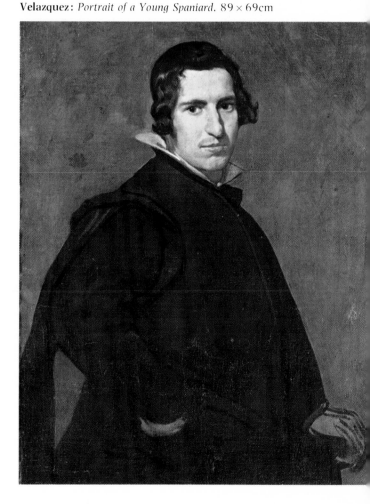

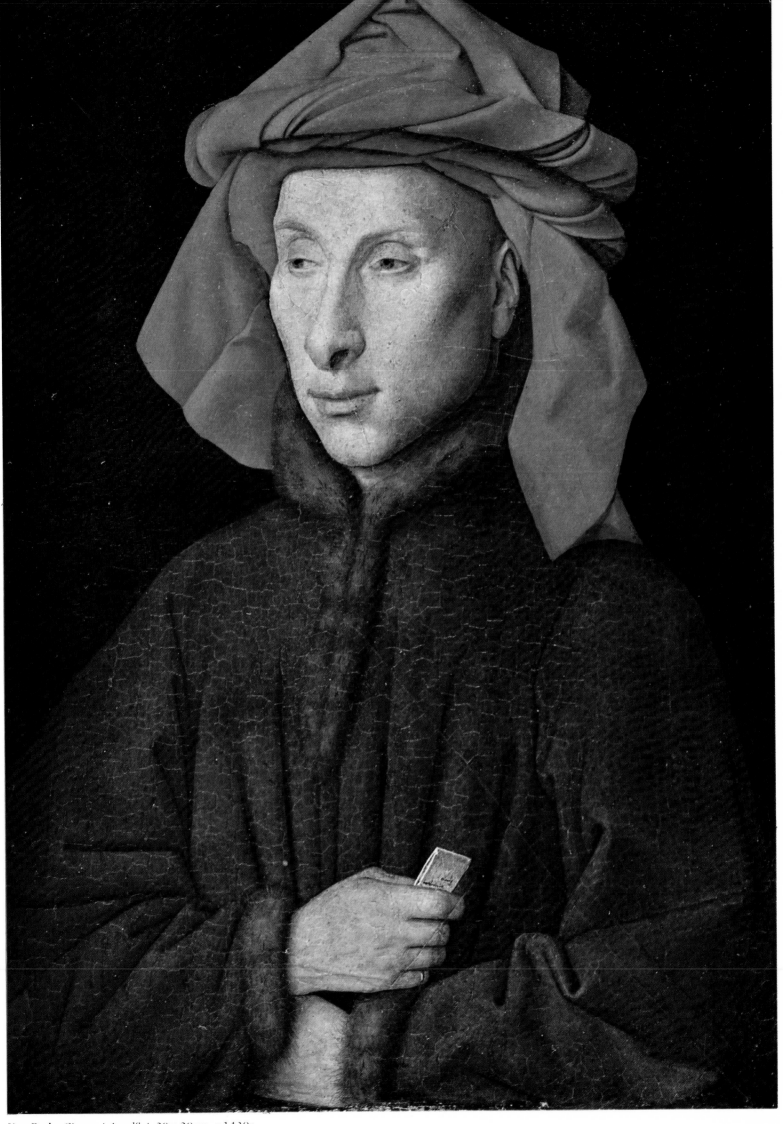

Van Eyck: *Giovanni Arnolfini.* 29 × 20cm. c.1430s

what that personality is like? When we meet a person we rarely base our impression of his character purely on his physical appearance. What we already know about him, what he says and how he acts are of far greater importance. But deprived of these clues as we are with a portrait, we inevitably look to the facial features. Antonello's *Portrait of a Man* in the Louvre, for instance, has traditionally been identified as a *condottiere*, a mercenary soldier, solely on the

Dirk Jacobsz:
Pompejus Occo,
66 × 54cm, c.1531

Titian: *Young Man with a Glove*, 100× 89cm, c.1520–2

The humours were an early system of psychological types. Every man was supposed to tend towards one of four temperaments which corresponded with the elements: the choleric was associated with fire and thus passion, the sanguine with air and buoyancy, the phlegmatic with water and coolness, the melancholy with earth and depression. Portraits sometimes refer to this concept to make sitters' characters explicit.
A mournful look comes easily during long sittings, but, more importantly, melancholia has always been the most fashionable of the humours. It is sometimes indicated simply, as in the works here by Titian and Romanino, by the sitter's wistful expression and sombre dress. The sixteenth-century writer Lomazzo suggested that melancholy was best shown by a heaviness in the arms, which should 'hang down as if numb with cold'. Other signs were the sitter's leaning his head on his hand, pointing to his spleen which was thought to be the source of melancholy feelings, and resting his hand on a skull symbolizing his consciousness of mortality.

basis of the 'cruel' and 'domineering' expression on the face: the telling features are clearly the rather high-set mouth and the jutting chin.

The notion that character can be deduced from the face is the fundamental assumption of the 'science' of physiognomy. According to the celebrated eighteenth-century physiognomist Lavater, 'the countenance is the theatre on which the soul exhibits itself; here must its emanations be studied and caught.' Furthermore, 'whoever cannot paint these is no portrait painter.' Lavater argues that the artist must be a physiognomist in order to differentiate between transient expressions due to 'the moveable, the muscular

OPPOSITE **Antonello da Messina:** *Portrait of a Man* (detail), 1475

Romanino: *Portrait of a Man*, 82·5 × 71·5cm, c.1515–20

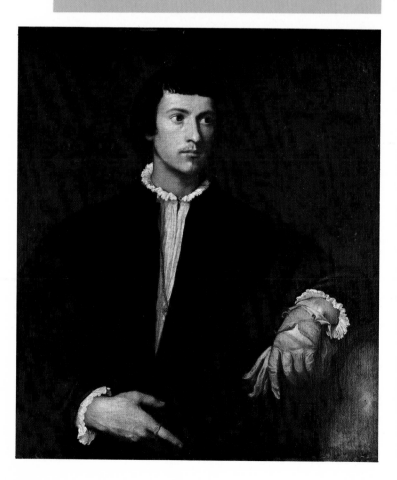

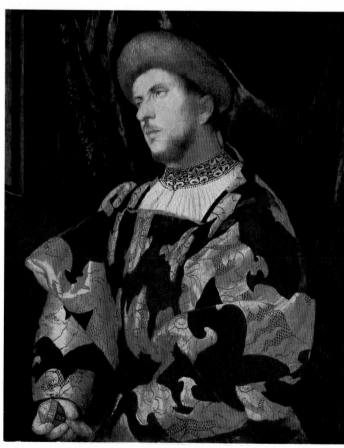

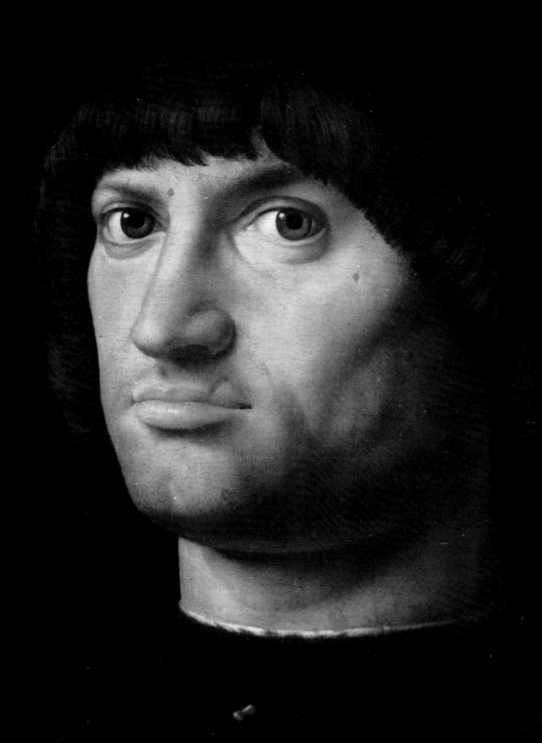

features', and the characteristic expression or 'grand outline of the countenance'. The latter concept is reminiscent of one which has already been mentioned, that of the 'ideal of a man'. We have said that we expect a portrait to capture the look of a person. But we must add the qualification that opinions as to what this look is, are notoriously subjective. For example, the portrait which seems a good likeness to a man's wife may be quite unacceptable to his mother. Lavater's fallacy is his belief that there is such a thing as the 'grand outline of the countenance' which can be discerned

objectively and without prior knowledge. If a person's face is constantly changing how can the portraitist isolate a single characteristic expression, unless it is on the basis of preconceptions about the person's character?

Nevertheless, when we look at a portrait we do tend, because of its lifelike 'presence', to respond to it as if it were a fairly objective account of the sitter, something in fact like Lavater's 'grand outline'. If we then proceed to attempt to read the character, we make an equally dubious assumption. This is that the way in which we interpret expressions of

Hogarth: *The Artist's Servants.* 61 × 74cm, mid-1750s

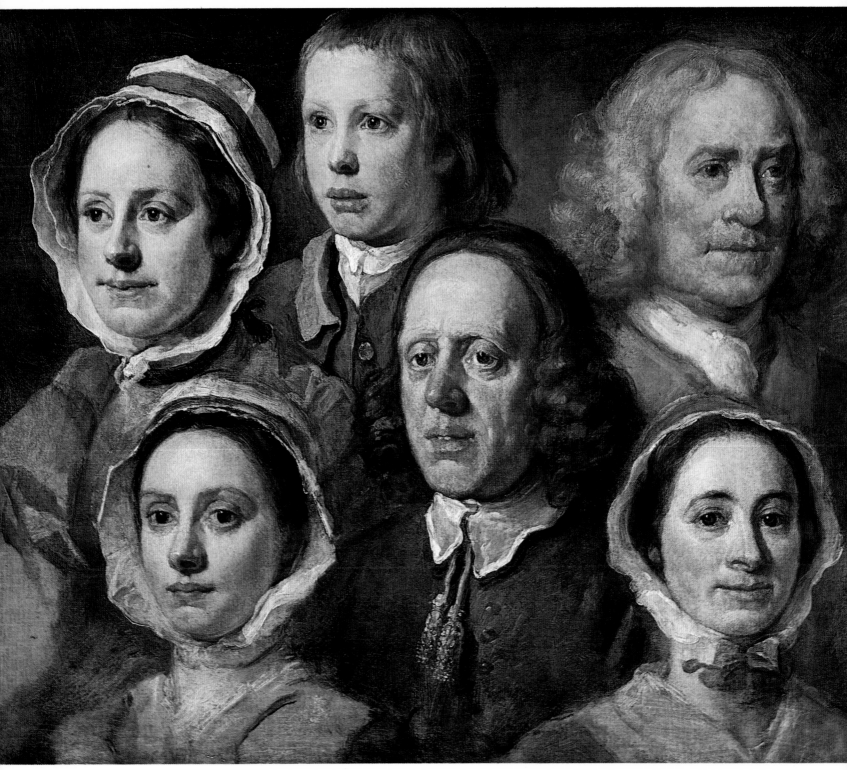

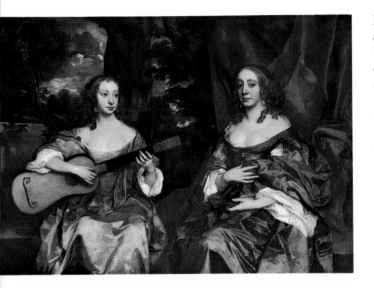

Lely: *Two Ladies of the Lake Family*, 127×181cm, c.1660

The poet Dryden said that Lely 'drew many graceful pictures, but few of them were like, and this happened to him because he always studied himself more than those who sat to him'. Portraits such as this do indeed tell us more about Lely and his liking for a certain plump, pop-eyed type, than about the sitters. The ladies are differentiated not by their faces but by their trappings: the one in cool colours and the other in warm, the one with a landscape behind her and the other with a curtain, the one engaged in an activity – playing the guitar – and the other passive. Lely probably picked up this technique of contrast from works by Van Dyck such as the *Self-portrait with Endymion Porter*. Van Dyck's preference was for a very different facial type, with long and nervous features suggestive of aristocratic refinement. The artist himself clearly aspired to this quality and chose to cast his own face in the same mould. Here he also adopts the convention of having one glove on and the other off, which was a mark of high social rank. Gloves were a luxury which implied that the wearer was rich and also, in this case questionably, that he did not work with his hands.

he projects into his sitters' features can be related to his aesthetic ideas. We have seen this to be the case with Reynolds. Similarly, Hogarth's preference for the rounded, even rather pudgy face with wide eyes and curvaceous lips, accords with the principle of the gently winding 'line of beauty' expounded in his book, *Analysis of Beauty*. The type may simply be that to which the artist feels himself most physically attracted. This is especially so with a female sitter; painting the favourite type into the woman's features may in fact involve a degree of sexual wish-fulfilment. More mundanely, sheer mass-production may lead to a standardization of the product. Some portraitists have been in great demand and immensely busy: there have even been instances of painters working up a stock of portraits which could be adapted to suit any customer by inserting the appropriate features. This way of working hardly makes for strongly individual likenesses.

The favourite type often turns out to look very much like the artist himself. Judging on the basis of his self-portraits, for instance, it would be easy to believe that Hogarth's group portrait of his servants in fact represented some of his relatives. Here the resemblance may be due to the fact that a preference for a type also influenced the artist's self-portraits. With Manet's *Emile Zola* we have the evidence of contemporary photographs which show that the portrait actually resembled Manet almost as much as the sitter. 'As I sat there,' Zola recalled, 'I looked at the artist standing at his easel, his features taut, his eyes bright, absorbed in his work. He had forgotten me; he no longer realized I was there.' The obtrusion of Manet's features resulted from his involvement with the act of creation: he made Zola literally in his own image.

As we might expect, there is a special sense of rapport in portraitists' images of their fellow artists. Francisco Bayeu in Goya's painting of him, is the embodiment of pride of being a painter. Bayeu was one of Goya's first teachers; they remained on close terms, and Goya married Bayeu's sister. The older artist was Director of the Academy of San Fer-

Van Dyck: *Self-portrait with Endymion Porter*, 119 × 144cm, c.1635

emotion is applicable to the interpretation of personality. Thus since jutting out one's chin towards someone is normally a mark of aggression, a person with a permanently jutting chin, such as the so-called *condottiere*, is thought to have a pugnacious character. Of course the portraitist himself will often work on this assumption and make significant modifications in his sitter's features. Antonello, for example, may have exaggerated the chin in the *Portrait of a Man* in order to bring out an aggressive trait of personality. But since we will never see how the sitter really looked, we can never know if this was the case.

* * *

It has often been observed that portraitists tend to make their sitters look as if they belonged to the same family. An artist cannot alter his style to suit every individual face, and so a certain uniformity is inevitable. Sometimes the type which

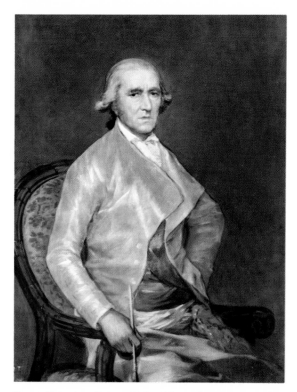

Goya: *Francisco Bayeu,* 112 × 84cm, 1786

nando, the artists' professional organization in Madrid, and Goya was appointed Deputy Director in the year before this portrait was executed. A comparable relationship seems to have existed between the young El Greco and Giulio Clovio, a manuscript illuminator who befriended him and helped him secure patronage. In his portrait Clovio is shown pointing to one of his own works, the *Hours of the Madonna.* He is obviously real and the book is art, but the strangely agitated landscape in the upper right corner occupies an ambiguous position between the two. This kind of reflection on the nature of art itself is typical of a large proportion of artists' portraits.

Derain's *Henri Matisse* shows the painter in the style of his own work. At the time of the portrait the two artists were

El Greco: *Giulio Clovio,* 63 × 88·5cm, c.1571–3

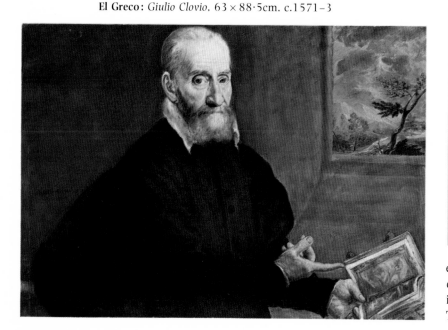

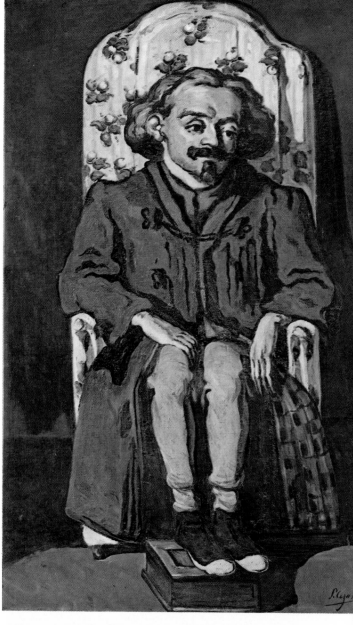

Cézanne: *Achille Emperaire,* 200 × 122cm, c.1868

Emperaire was an older artist from Cézanne's home town of Aix-en-Provence. He was a dwarf, in whose crippled body Cézanne found a symbol for his own feelings of impotence and isolation. The vivid contrasts of colour and tone give a slightly macabre effect, which is reinforced by the puppet-like limpness of the body. The sitter's names could hardly have been less appropriate, with their associations of heroism (Achilles) and power (the surname is close to *empereur*). This is exploited by Cézanne in the mock grandeur of the inscription — 'Achille Emperaire Painter' — and in the way in which the chair ironically resembles an emperor's throne.

engaged together in developing a style of painting later dubbed 'fauve' ('wild'), in which colours were used in striking contrasts and without regard for actual appearances. The Cubists took even further the idea that art need not be

illusionistic. They built up pictures using a range of favourite elements, particularly the straight line with shading down one side, from which objects only half emerge, full of self-contradictions. Gris' portrait of Picasso is a tribute from a novice in Cubism to the acknowledged head of the school. It incorporates references to Picasso's own work of this time: the inclusion, for example, of fragments of profile in the head, which is basically shown in full face. But the work is not a pastiche. Gris derived ideas about picture-making from Picasso, but applied them here in a purer and more obvious way than Picasso himself.

Of all the branches of art, portraiture is the most closely bound by the necessity of pleasing the customer. If a landscape does not appeal to one patron, the painter can always find another to buy it. A rejected portrait is virtually unsaleable. The portraitist is hence at the mercy of his patron's demands such as last minute requests to include the family dog. This is another of the reasons why portraiture has been looked down upon by those who feel that art should be the free exercise of the imagination. In works, such as Derain's *Matisse* and Gris' *Picasso*, the sitter's being a like-minded artist enabled the portraitist to take a more experimental approach than would have been possible with a normal commission. This is clearly even more the case with self-portraits, in which artist and sitter are one and the same.

Derain: *Henri Matisse*, 47 × 35cm, 1905

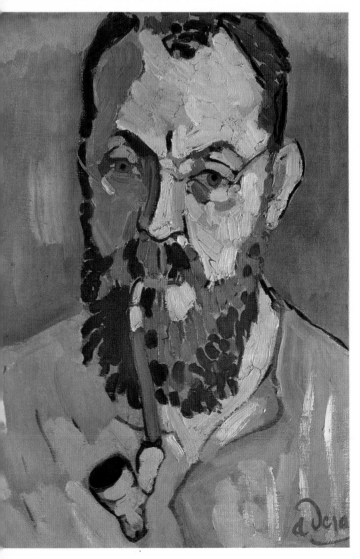

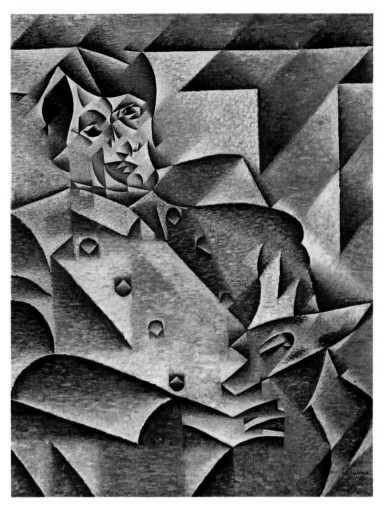

Gris: *Pablo Picasso*, 74 × 93·5cm, 1911–12

Typically, self-portraits first appeared as an incidental aspect of other kinds of art. Manuscript illuminations, for instance, often contain a diminutive figure somewhere in a margin which represents the scribe who produced the work. The artist sometimes shows himself presenting the manuscript itself to his patron, an archbishop perhaps, or a king, and kneeling to do so in a manner reminiscent of donor portraits in altarpieces. Artists also used their own features for the face of St. Luke, who was supposed to have been an artist himself and is commonly depicted at work on a portrait of the Virgin and Child. Crowd scenes were another pretext for self-portraits; Botticelli's self-portrait in his *Adoration of the Magi* is characteristic. Just as an artist's signature normally appears in the corner of his work, so his self-portrait — another kind of signature — comes at, or near, the edge. He invariably looks out at us as he might in life, inviting our admiration of his work. The first painter to make self-portraiture an independent art was Dürer. In his *Self-portrait*, in Munich, Dürer deliberately gave himself a Christ-like appearance. He possibly intended to suggest a parallel between God and the artist, both of whom are creators. Self-portraits such as this tell us a great deal about artists' conceptions of their own status. The rise of self-portraiture in

OVERLEAF, LEFT **Dürer**: *Self-portrait*, 67 × 49cm, c.1506

OVERLEAF RIGHT **Botticelli**: *Self-portrait* (detail of *The Adoration of the Magi*), c.1475

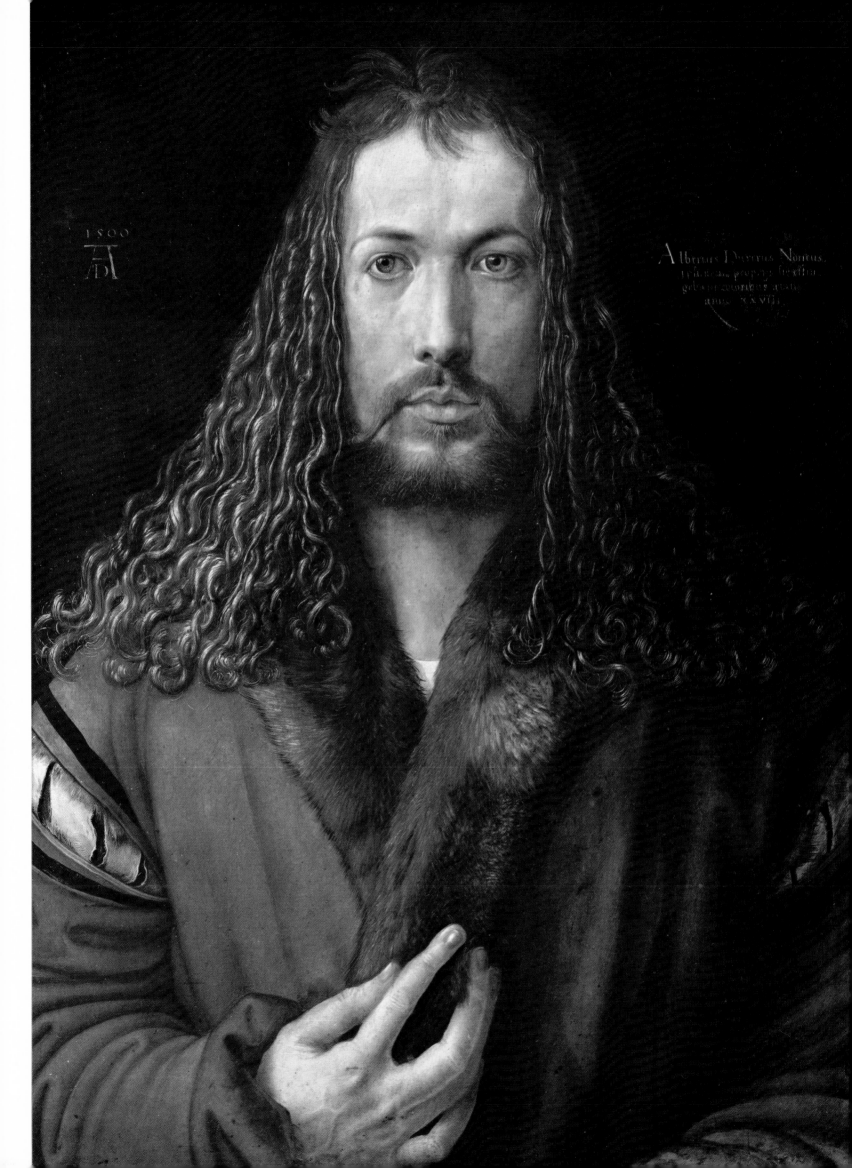

Albertus Durerus Noricus
ipsum me propriis sic effin-
gebam coloribus aetatis
anno XXVIII.

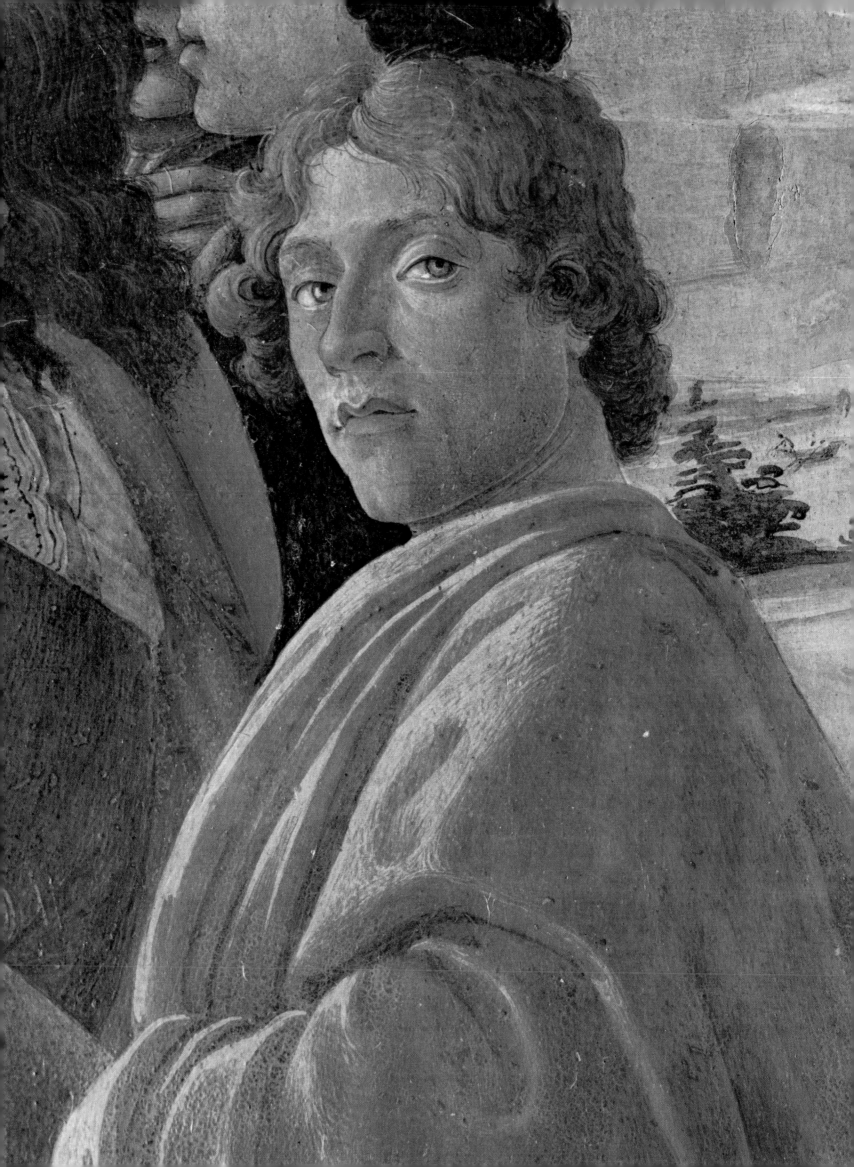

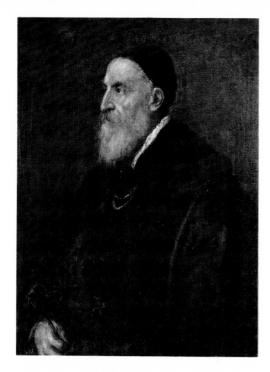

Titian: *Self-portrait,* 86 × 65cm, c.1565–70

the early sixteenth century was in itself symptomatic of an elevation in their social position. The next important stage after Dürer's came when painters began unashamedly to include such attributes such as palettes, brushes, easels. These have continued to be indications of professional pride

Ingres: *Self-portrait,* 64 × 53cm

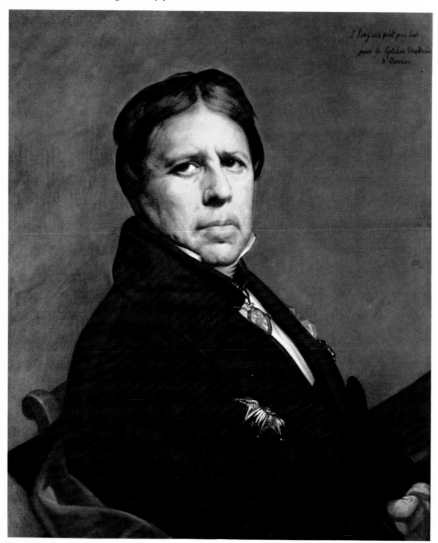

in self-portraits like that of the German painter, Anton Graff.

Occasionally the self-portrait is made from a portrait by another artist, or in more recent times from a photograph. But by far the commonest means is simply by using a mirror. This explains the tendency for the eyes to look straight out at us and the often slightly odd position of the hands. In Van Gogh's *Self-portrait,* for instance, the hand holding the palette is quite unconvincing. The artist was right-handed and held his palette in his left hand; the latter of course would appear to be his right when reversed in the mirror. To make a true image of himself Van Gogh therefore had to 'correct' the hand by painting the reverse of what he saw. When an artist chooses not to make such a correction, his left hand in the portrait (in fact, his right) tends to be placed so that it can be moved comfortably up to the picture's surface and back as he works. The Dürer *Self-portrait* in the Louvre exemplifies this well: the twig in the working hand is obviously a disguised paintbrush. Profile self-portraits such as Titian's are

Graff: *Self-portrait,* 168 × 105cm, 1794–5

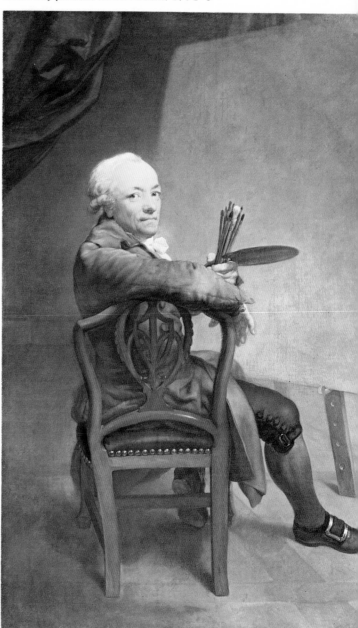

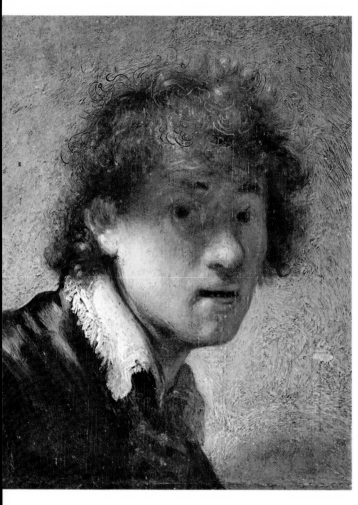

Rembrandt: *Self-portrait*, 84 × 66cm, 1659

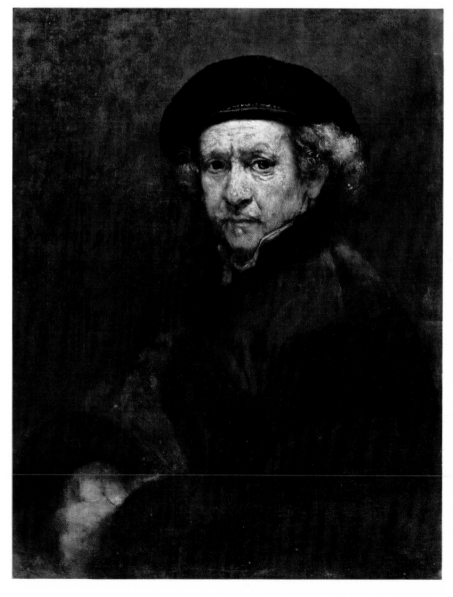

relatively rare. They involve the use of two mirrors, and the image from which the artist works is therefore much smaller (apparently further away) and dimmer.

In certain respects the artist is his own best model. He is always available, and sits free of charge for as long as is necessary for the completion of the work. Self-portraits are hence often made out of convenience by the painter, in order to keep in practice or try out some new idea. If the artist makes self-portraits regularly – Rembrandt made about two every year during his working life – they have the additional value of being a visual diary. It is always fascinating to see how one has changed with age. A good self-portrait can also serve as an advertisement for the artist's skills: it may be shown to prospective customers for portraits who can judge the likeness by direct comparison with the original. Titian's *Self-portrait* is said to have been made at the request of friends and relatives, but it was later acquired by Philip IV for the Spanish royal collection, which already contained a number of Titian's works. Self-portraits are often actually commissioned for this same purpose, to hang among the artist's own pictures. In addition, many collections of self-portraits have been brought together, and some works have been painted specifically for them. Artists' academies in particular frequently have their members contribute their own likenesses. The most notable private collection was that of Cardinal Leopold de' Medici, for which the Rembrandt *Self-portrait*, in the Uffizi, may have been commissioned. The works assembled by the Cardinal formed the basis of the famous gallery of self-portraits at the Uffizi in Florence.

An artist may have one or more of a number of private

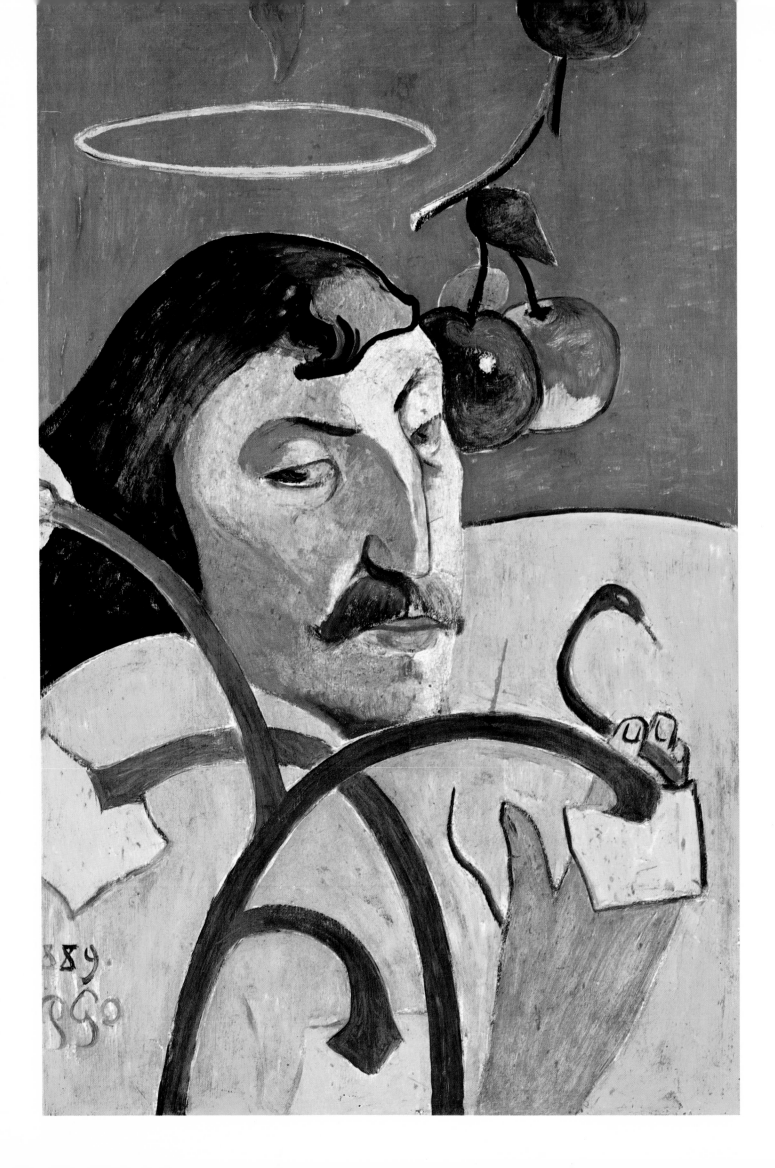

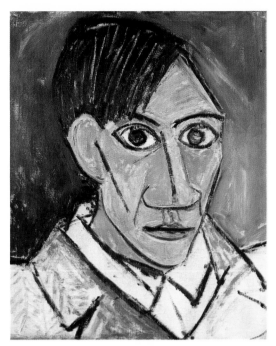

Picasso: *Self-portrait*. 56 × 46cm. 1907

Page 64. **Van Gogh:** *Self-portrait*, 65× 54·5cm, 1890

About the time of this work Van Gogh wrote to his sister: 'I should like to paint portraits which would appear after a century to the people living then as apparitions. By which I mean that I do not endeavour to achieve this by a photographic resemblance but by means of our impassioned expressions — that is to say, using our knowledge of and our modern taste for colour as a means of arriving at the expression and the intensification of the character . . .' Whereas Rembrandt makes the head stand out in his self-portraits and gives it expression by opposing lights and darks, Van Gogh uses the contrast between hot and cold colours. These of course carry symbolic connotations: here the red-orange of the beard is associated with fire and passion, the background suggests eddying water and coolness. This was the last of Van Gogh's series of over thirty self-portraits.

motives for making self-portraits: a desire for self-knowledge, perhaps a need to create an alternative identity, or mere narcissism (Narcissus fell in love with his own image reflected in the waters of a spring). A large proportion of self-portraits, however, are undeniably exhibitionist in character. Le Douanier Rousseau called his *Self-portrait* a *portrait-paysage* (portrait-landscape), a branch of painting which he preposterously claimed as his personal invention. He shows himself as a giant — compare him with the two figures in the lower left corner — dominating a Parisian setting which includes the Eiffel Tower, and on his jacket he proudly displays the purple button which identifies him as an *officier de l'instruction publique*. There is an inertia about self-portraiture. Taken together, self-portraits constitute a 'Hall of Fame', an idea which is attractive to artists who wish to align themselves with the great figure of the past.

Before the nineteenth century the artist was someone who made a living by providing a service which was in demand. Calling him fashionable was a compliment. In more recent times the word has become positively insulting. A premium is put on sincerity, and the serious artist must be true to his personal vision regardless of all other considerations. This attitude is not generally conducive to portraiture, which, as we have seen, usually imposes certain constraints on the artist. In this century the portrait has hence tended to be the

Gauguin: *Self-portrait*, 79·5× 51·5cm, 1890

Like Dürer, Gauguin painted himself as Christ. Here he appears in the opposite role, as Satan. The work is typical of the artist in its play on solidity and flatness: the head is in three dimensions and the hand (lower right) in two. The yellow represents Satan's wings — he was a fallen angel — against a red background suggestive of hell-fire. The apples and the snake refer to his part in the Fall of Man.

'Le Douanier' Rousseau: *Self-portrait*. 146 × 113cm. 1890

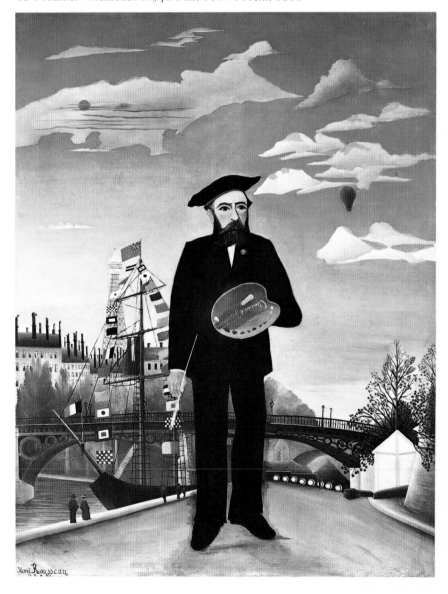

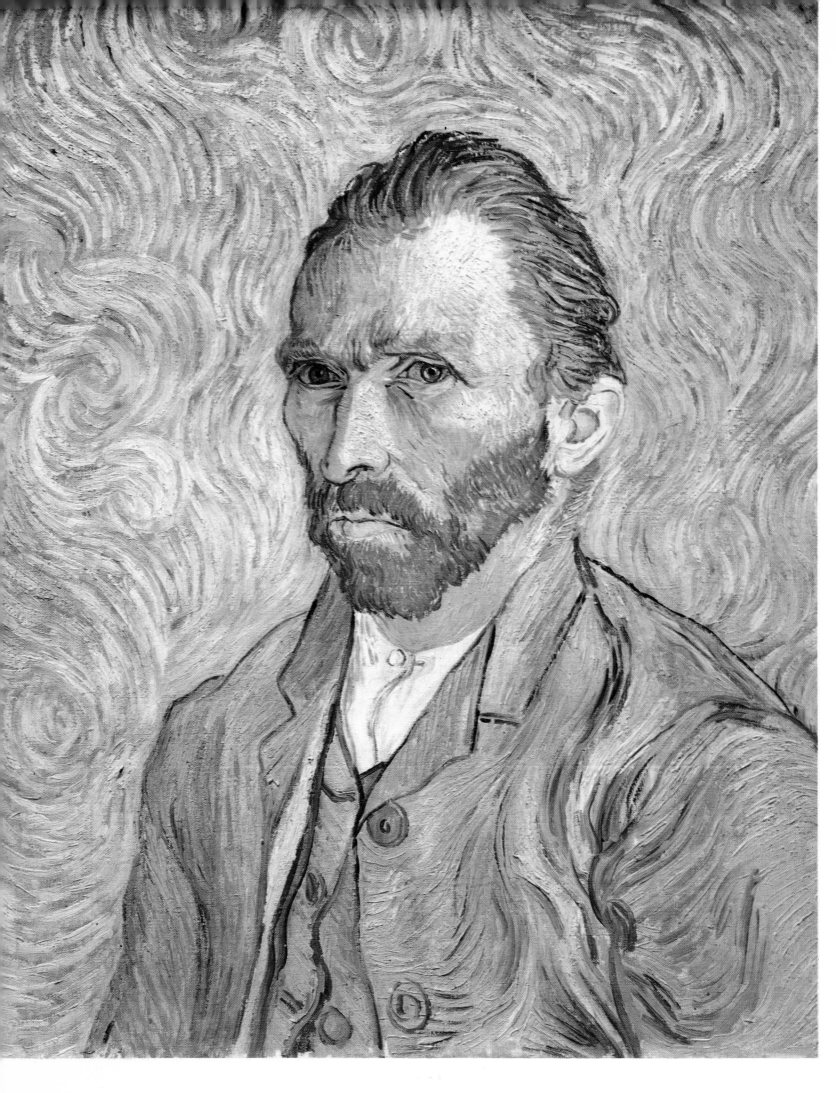

Van Gogh: *Self-portrait*, 60 × 48·5cm, 1889 ▶

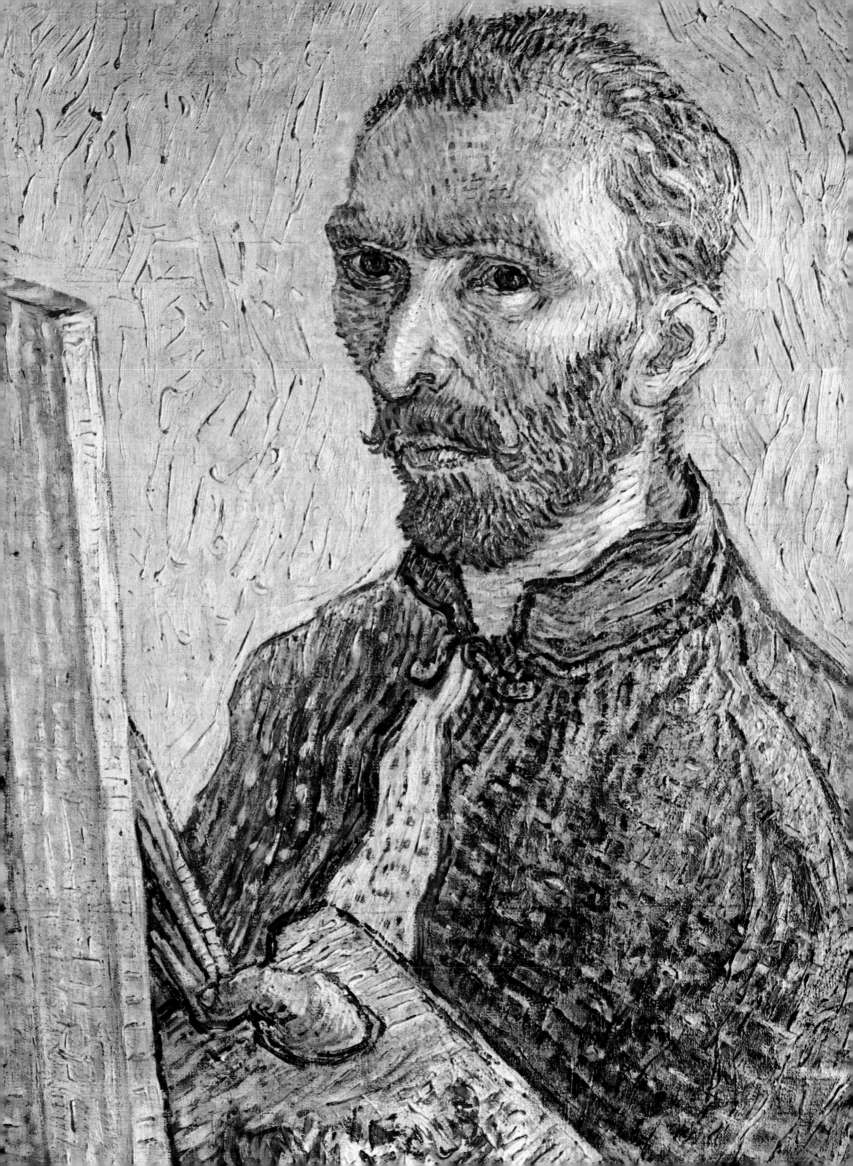

Beckmann: *Self-portrait*, 192·5× 89cm, 1937

The artist portrays himself in white tie and tails on a staircase at a ball. The effect is that of a Freudian dream-image. Beckmann was drawn to self-portraiture as a means of defining his psychological identity. In a lecture which he gave in 1938 he spoke of the ego as 'the great veiled mystery of the world. Its path is, in some strange and peculiar manner, our path, and for this reason I am immersed in the phenomenon of the individual . . . What are you? What am I? These are the questions that constantly persecute and torment me and perhaps also play a part in my art.'

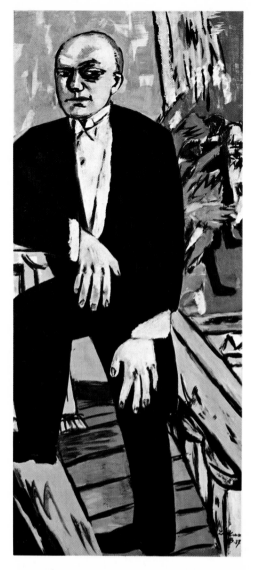

province of 'compromising' specialists working in a conservative style, and of course of photographers. Artists of the *avant-garde* have continued to produce some portraits but they choose their sitters rather than vice versa, and these are almost exclusively people with whom they have a special relationship, particularly friends and relatives. Such is the case, for example, with Chuck Close.

Since art has become more personal than ever before, the self-portrait is the form of portraiture which is most characteristic of the twentieth century. Picasso's *Self-portrait* in Prague is related in style to his famous *Les Demoiselles*

Chagall: *Me and the Village*. 187·5 × 147·5cm. 1911

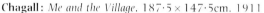

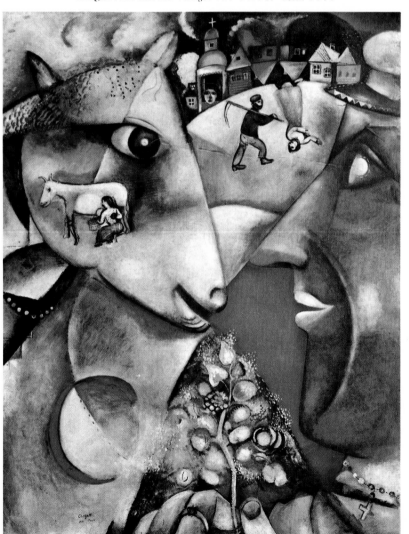

Velazquez: *Las Meninas*, 318× 276cm, 1656

The proliferation of paintings of artists in their studios in the seventeenth century was a further symptom of their increasing status. Velazquez shows himself, palette in hand, to the left of the composition. In the centre is the Infanta (Princess) Margarita, attended by her two maids-of-honour, or *meninas*, who give the work its title. Her entourage is completed by two dwarfs to the right — these were popular at courts — and two adult attendants behind. The mirror in the background reflects the figures of Philip IV and Queen Mariana. The question of what is actually happening in the picture has been the subject of much debate. The King and Queen are clearly in the position of sitters. Velazquez's canvas seems too large for just two figures, however, which suggests that the Infanta may have arrived to sit for a group portrait with her parents. The idea of the work may have been inspired in part by Van Eyck's *Arnolfini Marriage Portrait*, which was in the Spanish royal collection at this time. Van Eyck had shown his sitters in the real space of the picture and himself in the background mirror; Velazquez reversed the arrangement. After Courbet's *Studio of the Painter*, studio scenes became popular among painters of the *avant-garde*. Characteristically these tend to show artists not with their patrons like *Las Meninas*, but in the company of like-minded friends.

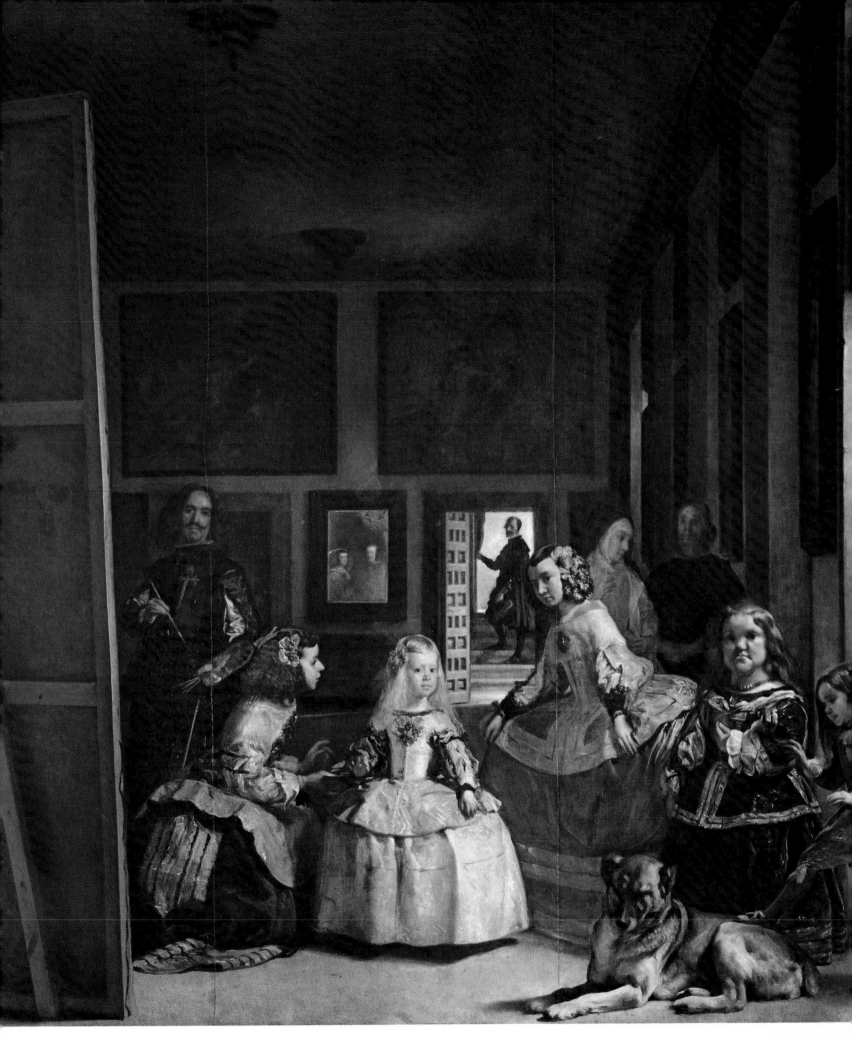

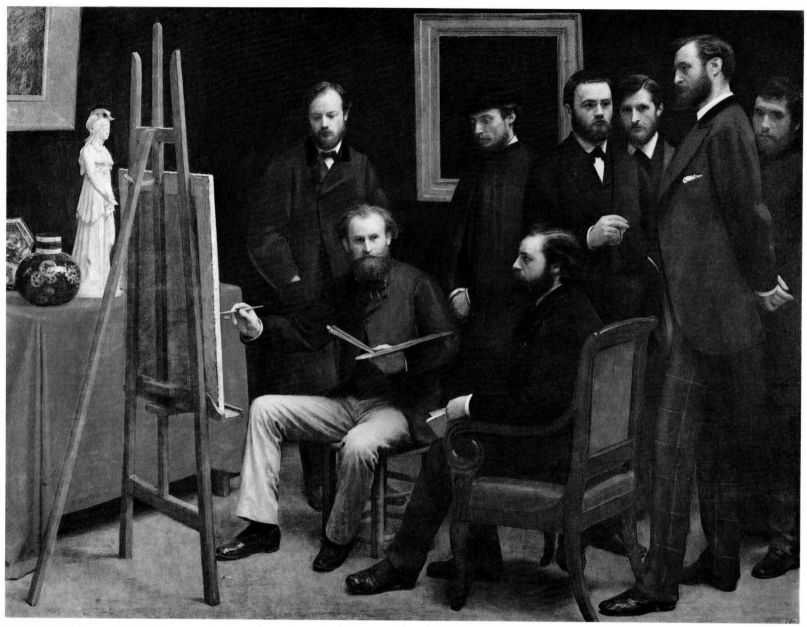

Fantin-Latour: *A Studio in the Batignolles Quarter*, 204 × 273·5cm, 1869–70

Bazille: *The Artist's Studio, Rue de la Condamine*, 98 × 128·5cm, 1870

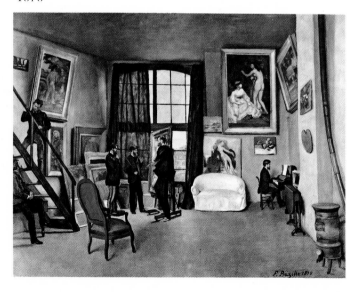

d'Avignon. The enlarged and heavily drawn eyes imitate primitive Iberian sculpture, and the planar simplification of the features, as if they were cut from wood, is derived from certain kinds of African mask. The idiosyncratic aspect here is the style; with Chagall's *Me and the Village* it is the artist's memories and fantasy. The work is built up in a dream-like way with details of life in Chagall's native Vitebsk. Traditional concepts of portraiture, likeness and visual biography, are subordinated to imaginative self-expression.

*　　　*　　　*

'The eyes follow you around the room' is a remark heard frequently in art galleries. The effect occurs because pictures are two-dimensional. A flat image does not change its basic configuration when seen from the side, it merely appears in a squashed-up form. There is, therefore, no reason why a head which looks directly out at us should not do so from no matter what angle. However, we accept the head as *three-*

Gainsborough: *Lady Eardley*, 215 × 140cm, c.1766

68

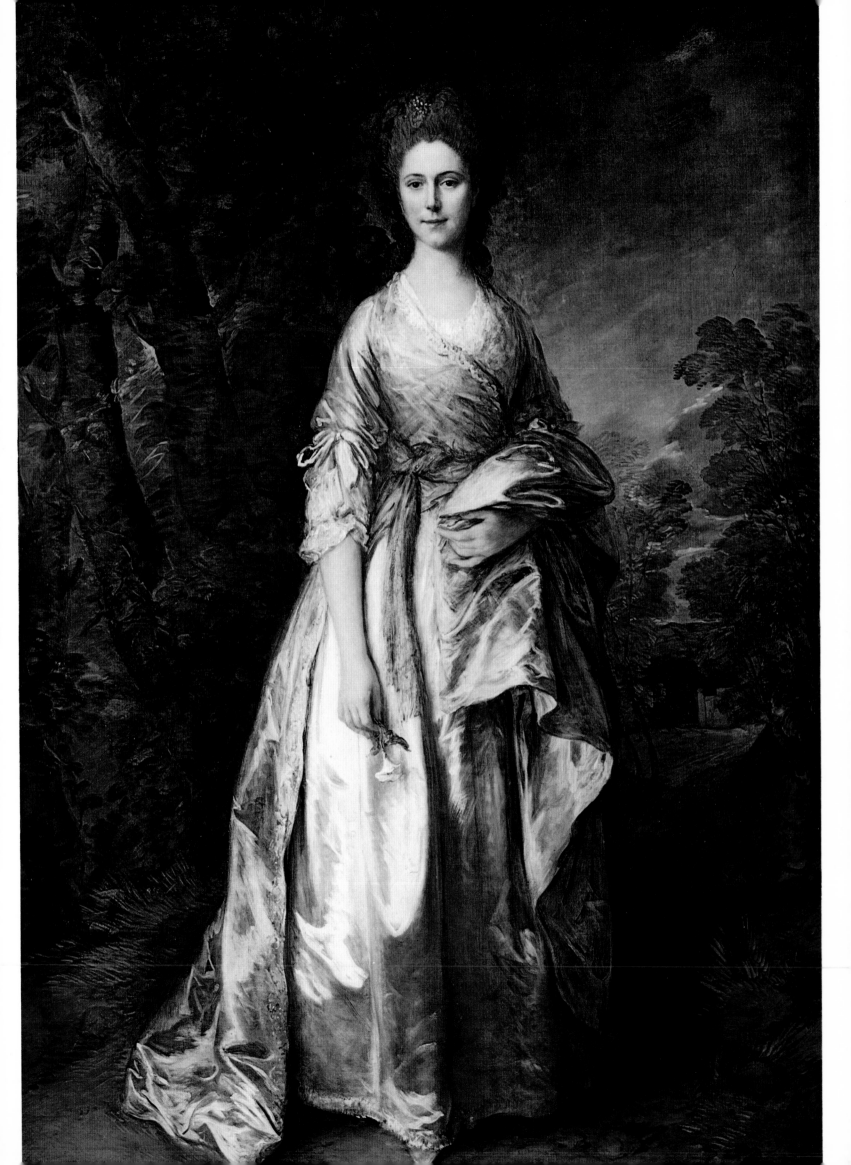

dimensional, and because it still looks at us even when we change our viewpoint, our minds jump to the conclusion that the eyes must be moving. In fact the whole head 'follows' us, but we find it much easier to believe that it is merely the eyes. They are naturally the focus of our attention and we know they are highly mobile; moreover, the lighting of the head would noticeably alter if it moved, which makes this possibility less acceptable. The phenomenon of the moving eyes illustrates that looking at portraits is not a passive business. The spectator is active, constantly reading things into the image and relating it to himself.

Joshua Reynolds perceptively remarked that the strength of Gainsborough's portraits derives from 'the great latitude which indistinctiveness gives to the imagination'. In his style there is 'enough to remind the spectator of the original; the imagination supplies the rest, and perhaps more satisfactorily to himself, if not more exactly, than the artist, with all his care, could possibly have done.' Those who knew Gainsborough's sitters could read likenesses into the indistinct features of his portraits. For us the ambiguity makes for greater likeness. When wiggly lines are drawn around a character in a comic cartoon we see him as trembling. The principle is the same; the painter provides us with a set of alternative contours for the face. Confronted with visual ambiguity we have a psychological tendency to opt for one reading at a time (many optical tricks are based on this); we do, however, switch between the different possibilities, and this gives an impression of animation in what we are looking at. Gainsborough's draperies similarly appear to shift and

Hals: *Portrait of a Man (Willem Croes?)*, 47 × 34cm, c.1658

rustle under our gaze. Frans Hals is another artist who deliberately uses ambiguity to suggest life and movement. Both Gainsborough and Hals worked in a very 'painterly' style, that is, they painted broadly and without drawing everything in beforehand. This manner obviously lends itself more naturally to the effect of animation than one in which forms are rigidly delineated.

Hals: *Portrait of an Officer*, 88 × 66cm, 1631

OPPOSITE **Hals**: *Portrait of Willem van Heythuyzen*, 48 × 38cm, c.1625

Pages 72–73. **Leonardo da Vinci:** *Mona Lisa*, 77 × 53cm, begun c.1503

The title is a contraction of *Madonna Lisa*, 'Lady Lisa' in archaic Italian. The painting is alternatively known by the sitter's surname, as *La Gioconda*: she was the wife of a Florentine merchant, Francesco di Bartolommeo del Giocondo. A good deal of the original colour of the work seems to have been lost; Giorgio Vasari, who saw it in the early sixteenth century, wrote that 'the mouth, related to the flesh-tints of the face by the red of the lips, appeared to be living flesh rather than paint'. Vasari also recorded that Leonardo 'employed singers and musicians or jesters to keep her full of merriment and so avoid the melancholy air that painters tend to give portraits'. The idea may have been suggested by the sitter's name – *gioconda* means 'jocund' – but the final effect of the work is, of course, far less definite than that of jocundity. The fact that Mona Lisa seems to be of no specific age may be due to Leonardo's having worked on the portrait over a period of four years.

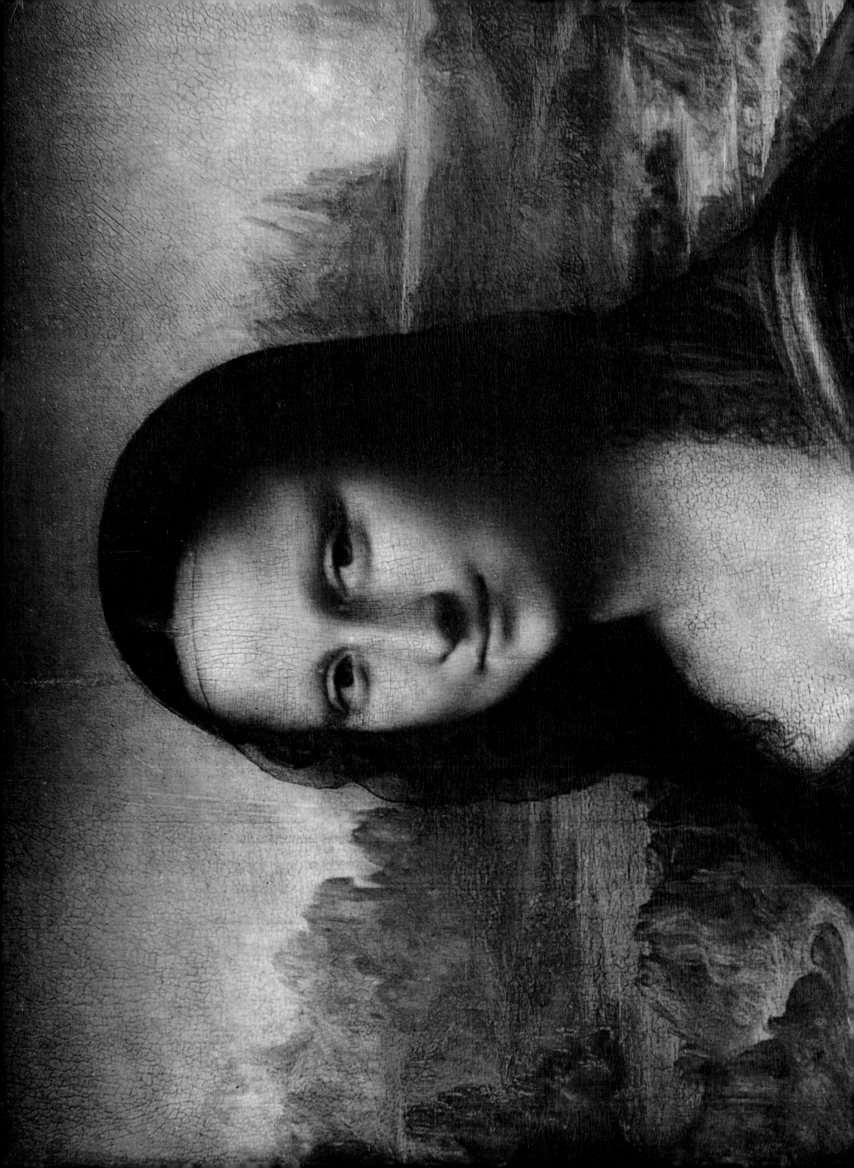

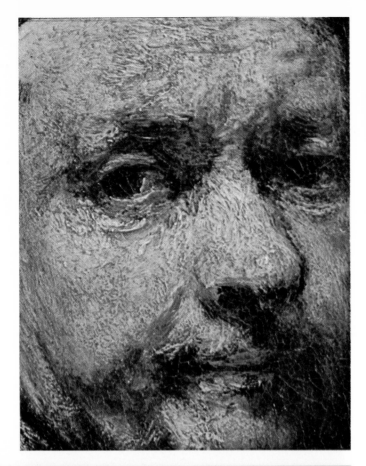

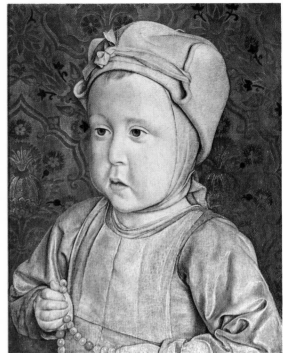

Master of Moulins: *Portrait of the Dauphin Charles Orleans,* 28 × 23cm

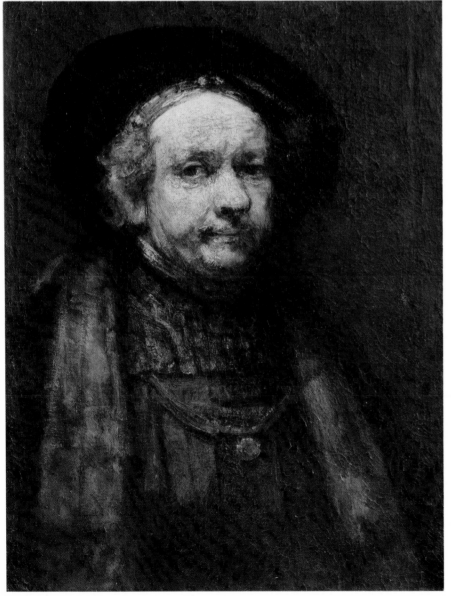

Rembrandt: *Self-portrait,* 102 × 73cm, c.1664–5 and detail

With Leonardo the technique is less free, but the ambiguity is just as effective. The Mona Lisa appears as if seen through a haze of smoke or a veil. Nothing is definite; forms do not begin and end, they emerge and fade away. This again mobilizes our tendency to plump for one reading at a time. The expression appears now as a friendly smile, now as an ironic smirk. Hence the famous enigmatic quality of the picture. Mona Lisa actually seems to know and respond to our thoughts and to our moods. This of course arises because some frames of mind predispose us to seeing the smirk, and others the smile. Our habit of projecting our feelings into ambiguous forms is exploited by certain psychological tests in which the subject is asked to say what a random ink mark reminds him of. The face of the Mona Lisa might almost be used for the same purpose.

Faces have a very special place in our experience. Babies

Raphael: *Baldassare Castiglione,* 62×67cm, 1516

Castiglione was the author of one of the most influential books of the sixteenth century, *The Courtier,* a kind of manual of gracious behaviour. In the conclusion Castiglione likens beauty to the rays of the sun. The good courtier makes himself a worthy subject of illumination by these 'divine rays' in displaying 'a certain gay harmony of different colours, supported by light and shade and by a measured distance and by limits of lines'. Raphael's portrait of Castiglione is just an image of balance and proportion. Direct eye-contact can appear aggressive – staring at someone is normally considered rude – but in such works as this the effect is counteracted by an impression of mobility in the features. The beard is useful here in making the contours of the lower part of the face vague, and obscuring the line of the mouth. The expression is hence subtly ambiguous. In fact the *Castiglione* illustrates another of the writer's own ideas: 'true art is what does not appear to be artful'.

Ghirlandaio: *Portrait of an Old Man and Child.* 62 × 46cm

have an ability to recognize and respond to the shape of a face. As we grow older we remain highly sensitive to any configuration which resembles a face. When we idly read images into the clouds, for example, the one we most readily see is that of a face; similarly we can see a 'man in the moon'. Of all the thousands of faces we see, no two look exactly alike. And we can detect a person's feelings from the slightest movements in his features. Of course, identifying and reading faces is a necessity of everyday communication, so it is not surprising that we are receptive to subtleties. But there is a peculiarity about our experience of faces which makes it not just unusually intense, but of a different kind from our experience of anything else. This is that we look at faces through another face – our own.

We are all familiar with the fact that when we see someone yawning we have a powerful urge to yawn too. The same is true of laughing and crying. The contagiousness of these marked expressions provides a key to understanding the unique way in which we respond to a face. We register the yawn or whatever expression we see, not only with our eyes but also, empathetically with our own facial muscles. This is why it is easy to mimic a person without having to adjust your face in a mirror. You need not even form any mental picture of his expression: you *feel* yourself into it. This empathy is another reason for the obtrusion of artists' features in their portraits. Because the artist experiences the sitter's face in his own face, their expressions can become conflated in the final image. Similarly, it is no accident that a person often happens to resemble his own favourite portrait. Empathy is an essential part of the spectator's experience too. We constantly empathize with the faces which confront ours, and attempt to identify ourselves physically with them. Portraiture is a collaboration between three people: sitter, artist and spectator. Having given some account of the part of the sitter and of the artist, it is appropriate that we should end by acknowledging our own.

Van Eyck: *Arnolfini Marriage Portrait* (detail), 1434

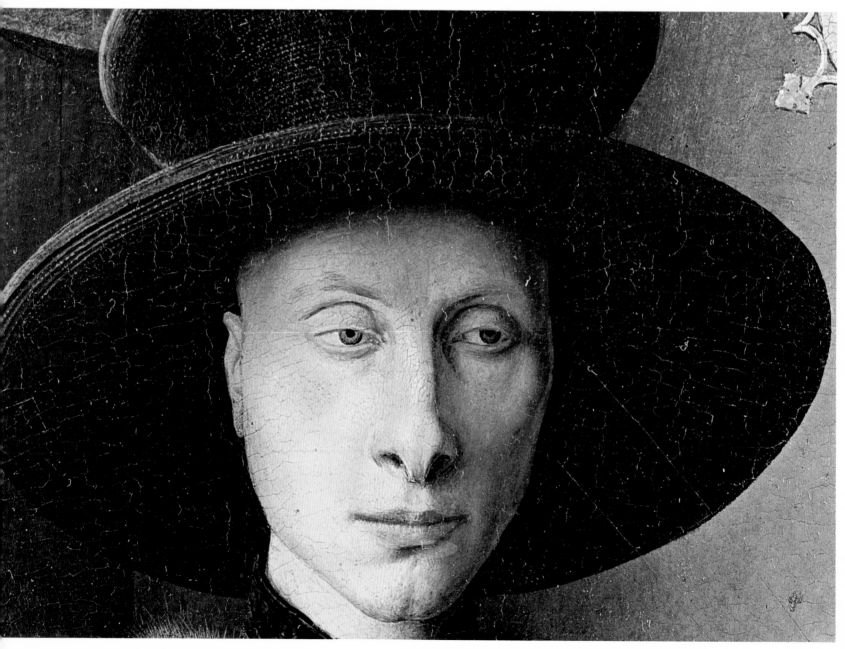

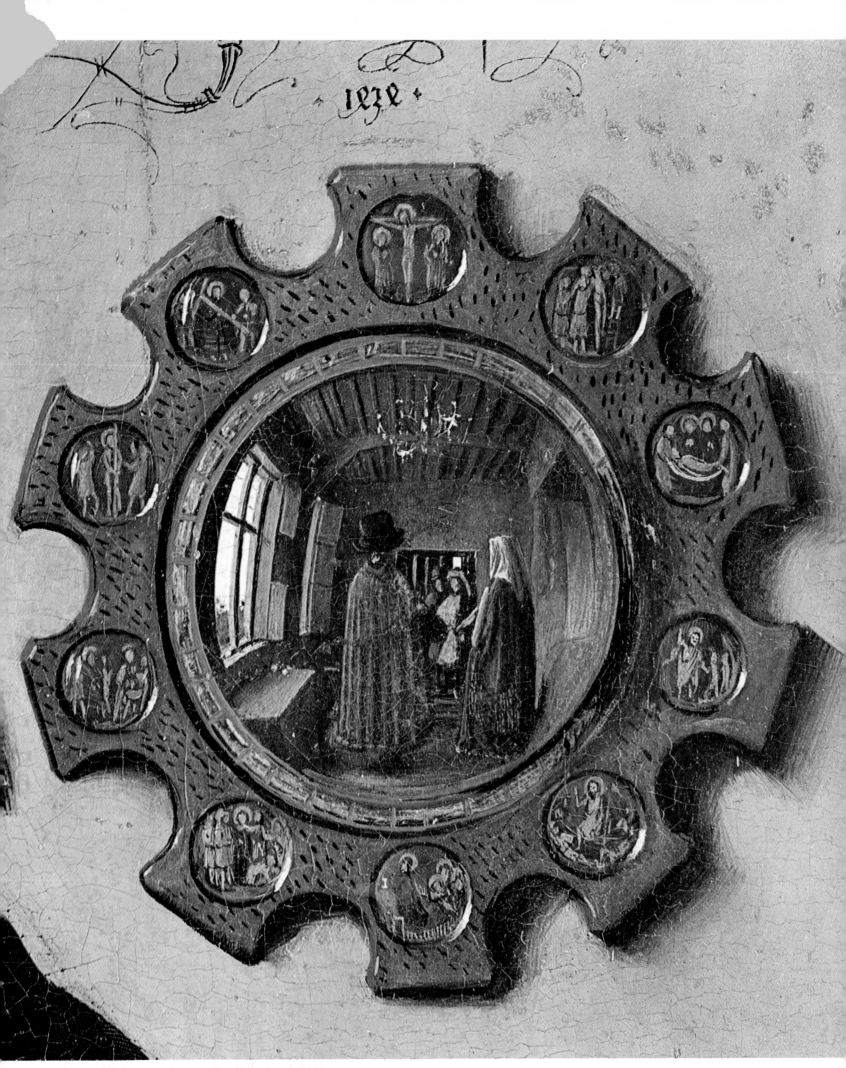

Van Eyck: *Arnolfini Marriage Portrait* (detail of mirror), 1434

List of illustrations

Bibliography

GIBSON, ROBIN: *Twentieth-Century Portraits*, exhibition catalogue of National Portrait Gallery, London, 1978
GOMBRICH, E. H.: 'The Mask and the Face: the Perception of Physiognomic Likeness in Life and Art' in *Art, Perception and Reality*, 1972
JENKINS, MARIANNA: *The State Portrait*, 1947
PIPER, DAVID: *The English Face*, 1957
POPE-HENNESSY, JOHN: *The Portrait in the Renaissance*, 1966
PRAZ, MARIO: *Conversation Pieces*, 1971